IMAGES
of America

TULSA'S HISTO
GREENWOOD DISTRICT

D0881396

IMAGES
of America

TULSA'S HISTORIC
GREENWOOD DISTRICT

Hannibal B. Johnson

ARCADIA
PUBLISHING

Published by Arcadia Publishing
Charleston, South Carolina

Printed in the United States of America

Library of Congress Control Number: 2013942833

For all general information, please contact Arcadia Publishing:
Telephone 843-853-2070
Fax 843-853-0044
E-mail sales@arcadiapublishing.com
For customer service and orders:
Toll-Free 1-888-313-2665

Visit us on the Internet at www.arcadiapublishing.com

This book is dedicated to the memory of Tulsa's Greenwood District pioneers, whose vision, resourcefulness, and resilience earned them national renown. Their lives and their legacy will never be forgotten.

CONTENTS

ACKNOWLEDGMENTS

The author wishes to extend a special thanks to I. Marc Carlson, librarian of Special Collections and University Archives, University of Tulsa, for lending his considerable photographic and archival talents to this book. Thanks also to the following individuals and institutions: Beryl Ford Collection/Rotary Club of Tulsa; Tulsa City-County Library; Dana Birkes; Mechelle Brown, Frances Fleming, and Frances Jordan, Greenwood Cultural Center; Tom Gilbert, chief photographer, *Tulsa World*; Vanessa Adams-Harris; Wes Johnson; Jean Neal, John Hope Franklin Center for Reconciliation; Ian D. Swart, archivist and curator of collections, Tulsa Historical Society; Steve Wood; and Joe Worley, executive editor, *Tulsa World*.

INTRODUCTION

Tulsa, Oklahoma, "The Oil Capital of the World," shone brightly at the dawn of the 20th century. Black gold oozed from Indian Territory soil, land once set aside for Native American resettlement. J. Paul Getty, Thomas Gilcrease, and Waite Phillips were among the men extracting fabulous fortunes from Oklahoma crude and living on Tulsa time.

As Tulsa's wealth and stature grew, so, too, did its political, economic, and, in particular, race-based tensions. The formative years of this segregated city coincided with a period of marked violence against African Americans. In 1919 alone, more than two dozen race riots erupted in towns and cities throughout the country. That same year, vigilantes lynched at least 83 African Americans.

The Greenwood District in Tulsa blossomed even amidst this "blacklash." African Americans engaged one another in commerce, creating a nationally renowned hotbed of black business and entrepreneurial activity known as "Negro Wall Street." Greenwood Avenue, just north of the Frisco Railroad tracks, became the hub of Tulsa's original African American community. Eclectic and electric, this artery drew favorable comparisons to legendary thoroughfares such as Beale Street in Memphis and State Street in Chicago.

This parallel black city existed just beyond downtown, separated physically from white Tulsa by the Frisco tracks and psychologically by layers of social stratification. In it, African American businesspersons and professionals mingled with day laborers, musicians, and maids. African American educators molded young minds. African American clergy nurtured spirits and soothed souls.

The success of the Greenwood District ran counter to the prevailing notion in that era of black inferiority. Fear and jealousy swelled over time. The economic prowess of Tulsa's African American citizens, including home, business, and land ownership, caused increasing tension. Black World War I veterans, having tasted true freedom on foreign soil, came back to America with heightened expectations. Valor and sacrifice in battle had earned them the basic respect and human dignity so long denied at home—or so they thought. But America had not yet changed. Oklahoma had not changed. Tulsa had not changed.

A seemingly random encounter between two teenagers lit the fuse that set the Greenwood District alight. The alleged assault on a 17-year-old white girl, Sarah Page, by a 19-year-old black boy, Dick Rowland, in the elevator of a downtown building triggered unprecedented civil unrest. Deep social fissures, however, lay at the roots of the riot, which included white angst over African American prosperity, land lust, and a racially hostile climate in general.

A local newspaper stoked the embers of Tulsa's emerging firestorm. *The Tulsa Tribune* framed the elevator incident in black and white: "Nab Negro for Attacking Girl in an Elevator." Authorities arrested Rowland. A white mob vowed to lynch him.

A small group of African American men marched to the courthouse to protect Rowland. Upon their arrival, law enforcement authorities implored them to retreat, assuring them of the teen's safety. They left, but the lynch talk persisted. Jarred by these persistent threats and increasingly concerned for Rowland's safety, more African American men assembled. Several dozen strong, these men, some bearing arms, trekked to the courthouse. There, they met and verbally engaged with the throngs of white men already massed. Two men struggled over a gun. The gun discharged. Chaos erupted.

Soon, thousands of weapon-wielding white men invaded the Greenwood District, seizing upon the "Negro quarter" with seismic fury. Some law enforcement officers stood idly by while others

placed themselves squarely along the racial fault lines, even deputizing the white hoodlums who would set ablaze the area derogated as "Little Africa." As flames raged and smoke billowed, roving gangs prevented firefighters from taking action.

In a 16-hour span, people, property, hopes, and dreams vanished. The Greenwood District lay in utter ruin. The State of Oklahoma declared martial law in Tulsa. The Oklahoma National Guard eventually restored order.

Authorities herded African American men into internment camps around the city, ostensibly for their own protection. Camp staff released detainees only upon presentation of green cards countersigned by white guarantors.

Property damage ran into the millions. Casualties numbered in the hundreds. Some African Americans fled Tulsa, never to return. Local courts failed to convict even a single white person of a crime associated with the riot. Prosecutors charged dozens of African American men with inciting it.

Even as the fires still smoldered, Greenwood District pioneers pledged to rebuild their community from the ashes. Official Tulsa leadership touted cooperation and collaboration, but hindered post-riot reconstruction. The Tulsa City Commission blamed African American citizens for their own plight. City officials turned away outside donations earmarked for the rebuilding. Attorney Buck Colbert Franklin rebuffed Tulsa's attempt to enact a more stringent fire code that would have made post-riot rebuilding cost-prohibitive for many.

In the midst of the devastation, white allies surfaced. First Presbyterian Church and Holy Family Cathedral helped shelter and feed fleeing victims of the racial violence. The American Red Cross, heralded as "Angels of Mercy," offered medical care, food, shelter, and clothing, and even established tent cities for the hordes left homeless by the riot.

African Americans shouldered their share of the load, too. Spears, Franklin & Chappelle litigated claims against the City of Tulsa and insurance companies and made urgent appeals to African Americans nationwide for assistance. Black builders secured lumber and supplies from surrounding states so reconstruction could commence. Entrepreneurs vowed to reestablish their businesses. Black churches rallied their parishioners. For Tulsa's early African American denizens, the Greenwood District was much more than a business venue. It was home. Their determination and persistence ensured the survival of the community they knew and loved.

Tulsa's African American community proved remarkably resilient. In 1925, just four years removed from the riot, the community hosted the annual conference of the National Negro Business League. By the early 1940s, scores of businesses once again called the Greenwood District home. Integration, urban renewal, a new business climate, and the aging of the early Greenwood District pioneers precipitated a pronounced economic decline beginning in the 1960s. The emergence of the Greenwood Cultural Center in 1983 signaled a new beginning.

The modern Greenwood District is still emerging. In addition to the Greenwood Cultural Center, the Greenwood Chamber of Commerce and a smattering of small enterprises dot the 100 block of Greenwood Avenue. Two historic riot-era churches remain in the heart of the Greenwood District: Mount Zion Baptist Church and Vernon African Methodist Episcopal Church. A mixed-use property called Greenarch occupies the intersection of Greenwood Avenue and Archer Street. Oklahoma State University–Tulsa sits on the site of the original 1913 Booker T. Washington High School. Langston University–Tulsa and Oklahoma Educational Television Authority (OETA) Tulsa, a member station of the Public Broadcasting Service, are located to the north. ONEOK Field, named for Tulsa-based energy company, ONEOK, and home of the Tulsa Drillers minor league baseball team, occupies a block on the east end, while John Hope Franklin Reconciliation Park sits on the western boundary.

The story of the Greenwood District speaks to the triumph of the human spirit. Now, a new chapter has begun. The Greenwood District, that black entrepreneurial center of old, has long since faded. In its stead is a new incarnation: an emerging arts, cultural, educational, and entertainment complex. This book explores, principally through pictures, the four central phases in the life of Tulsa's historic Greenwood District: its roots, riot, regeneration, and renaissance.

One

ROOTS

A people without the knowledge of their past history,
origin, and culture is like a tree without roots.

—Marcus Garvey

Tulsa, "The Magic City," beckoned multiple souls in the early 1900s. These seekers, white and African American alike, shared a vintage American optimism. They sought a better life in oil-rich Tulsa. The African American community, situated in the Greenwood District, emerged amidst rigid racial separation. With growth came the need for commerce, education, and entertainment. A class of African American entrepreneurs filled the void.

Segregation propelled prosperity. The community's insular service economy rested on a foundation of necessity. Dollars circulated within constricted geographic boundaries. Dubbed the "Negro Wall Street" by Booker T. Washington, it became the talk of the nation.

The Greenwood District nurtured entrepreneurship and industriousness. Simon Berry started a nickel-a-ride jitney service, ran a bus line later purchased by the city, owned the Royal Hotel, and shuttled wealthy oil barons on his charter airline. Berry reportedly earned as much as $500 a day in his prime.

Dr. Andrew C. Jackson, a prominent surgeon, managed to breach the color line. Called the most able Negro surgeon in America by the Mayo brothers (of Mayo Clinic fame), Dr. Jackson treated both black and white patients. But his pedigree and reputation could not save him from the horrors of the riot. A teenager shot and mortally wounded Jackson as he exited his residence in surrender.

The Williams family also found economic success in the Greenwood District. The family owned several businesses, including the Williams Dreamland Theater, a rooming house, a confectionery, a garage, and rental property.

Educators like Ellis Walker Woods, principal of Booker T. Washington High School for over 35 years, earned respect and renown. Woods came to Tulsa by foot from Memphis, Tennessee, in answer to a call for "colored" teachers. Local press dubbed Woods the "quintessential Tulsan" for his preeminent leadership in the realm of public education. Throngs of mourners assembled at the Tulsa Convention Center for Woods's 1948 funeral.

The Greenwood District pioneers took full business advantage of Jim Crow. They seized the opportunity to disprove the inferiority myth through their own ingenuity. The success of the Greenwood District defied conventional wisdom. Such a brash display of black business acumen and economic prosperity could scarcely be tolerated, let alone embraced, by segments of the greater Tulsa community.

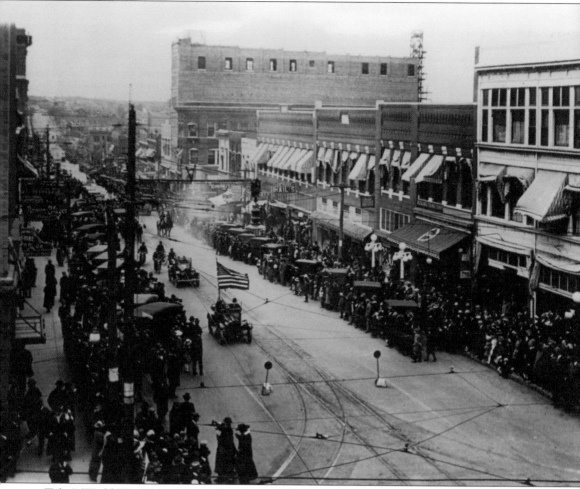

Tulsa's World War I Main Street Parade in 1917 honored patriots and encouraged young men to enlist in the armed forces in anticipation of the United States' entry into the war on April 6, 1917. This photograph was taken from the top of the Robinson Hotel. The building under construction is the Commercial Building, later home to Boswell's Jewelry on the bottom floor. The building on the right is the R.C. Daniel Building. Daniel purchased the building at the 1904 World's Fair in New York City and had it disassembled, shipped to Tulsa, and rebuilt. (Courtesy of the Beryl Ford Collection/Rotary Club of Tulsa, Tulsa City-County Library and Tulsa Historical Society.)

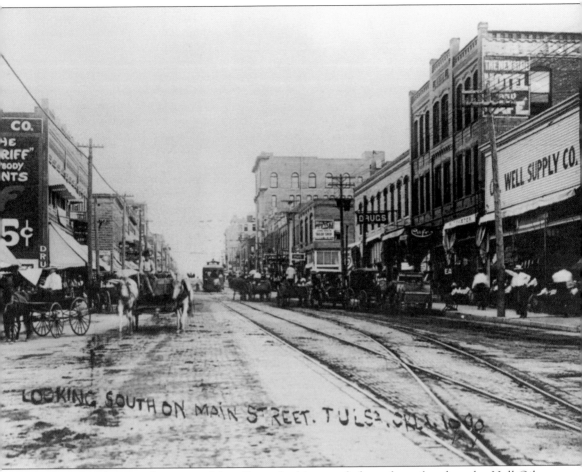

This 1909 photograph captures Main Street looking south from the railroad tracks. Hall Oil Well Supply on the right is a remodeled building. Builder James Monroe Hall constructed many of the buildings in this picture. At the rear is Tulsa's first telephone switching station. On the left is the Archer Building, which housed a 5¢ store. The stone building on the left was the first masonry building in Tulsa. By 1909, Tulsa boasted paved streets and streetcar lines. This image reveals a multi-modal Tulsa, with horse-drawn vehicles, an automobile, bicycles, and streetcars. (Courtesy of the Beryl Ford Collection/Rotary Club of Tulsa, Tulsa City-County Library and Tulsa Historical Society.)

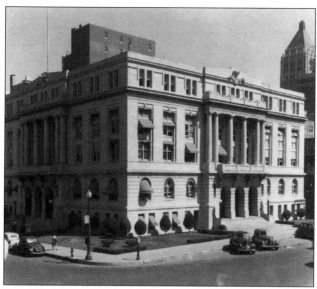

The Tulsa County Courthouse, built in 1912, sat on the corner of Sixth Street and Boulder Avenue. The space is now occupied by the Bank of America Building. The courthouse contained two courtrooms and a jail on the top floor. The 1921 Tulsa Race Riot began here. Armed deputies turned off the elevators and blocked the staircase as an angry white mob attempted to seize a black teenager, Dick Rowland, from the jail. This photograph was taken in 1941. (Courtesy of the Beryl Ford Collection/Rotary Club of Tulsa, Tulsa City-County Library and Tulsa Historical Society.)

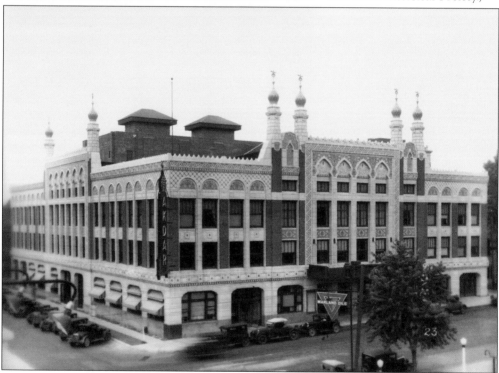

The Akdar Theater, located on the northeast corner of Fourth Street and Denver Avenue, opened on February 1, 1925. An audience of 1,800 viewed a performance of the celebrated Ziegfeld musical comedy *Sally.* This ornate venue showcased movies as well as "first class acts." The Tulsa Civic Symphony (later the Tulsa Philharmonic) premiered at the Akdar in 1927. Sold in the 1950s, the Akdar Theater became the Cimarron Ballroom. The facility was torn down in 1973. The foreground sign promotes Marland Oil. KRMG Radio and KVOO Television once occupied this building. (Courtesy of the Beryl Ford Collection/Rotary Club of Tulsa, Tulsa City-County Library and Tulsa Historical Society.)

W. Tate Brady, business owner and Oklahoma Democratic Party leader, epitomized wealth and power. He built the Brady Hotel in Tulsa in 1905, and later erected the Robinson Hotel. The Brady Hotel, touted as fireproof, burned in 1935. By some accounts, Brady had ties to the Ku Klux Klan (KKK) and participated, on at least some level, in the 1921 Tulsa Race Riot. (Courtesy of the Beryl Ford Collection/Rotary Club of Tulsa, Tulsa City-County Library and Tulsa Historical Society.)

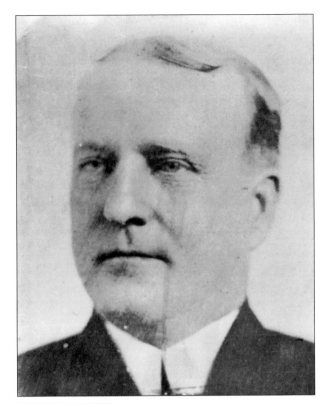

This is a c. 1900 portrait of John D. Seaman, one of Tulsa's early postmasters. His residence was located at Fourth Street and Cheyenne Avenue. Josiah Chouteau Perryman, the son of Lewis Perryman and a member of the part-Muscogee (Creek) Perryman family, was Tulsa's first postmaster. Tulsa's first post office opened in 1879 on George Perryman's property at Forty-First Street and Trenton Avenue. (Courtesy of the Beryl Ford Collection/Rotary Club of Tulsa, Tulsa City-County Library and Tulsa Historical Society.)

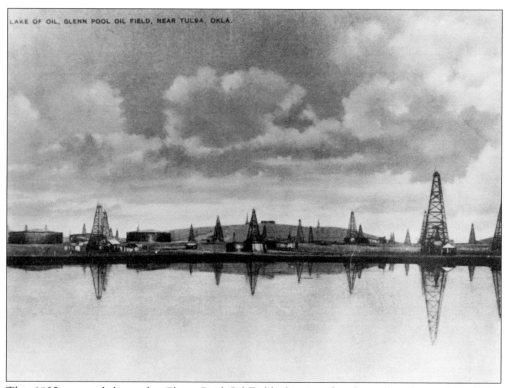

This 1905 postcard shows the Glenn Pool Oil Field, the site of gushers that changed the Tulsa area virtually overnight. The Glenn Pool, situated on the Ida E. Glenn farm some 12 miles south of Tulsa, catalyzed the Oklahoma oil industry. This breakthrough discovery brought in pipelines and capital investment. Nearby Tulsa became the epicenter of the oil business. In this image, the wooden oil derricks appear to reflect on a pool of water. That "water" is oil. Some of the gushers at the Glenn Pool happened prior to the building of storage tanks. As a result, these oil lakes were essentially collecting pools. (Courtesy of the Beryl Ford Collection/Rotary Club of Tulsa, Tulsa City-County Library and Tulsa Historical Society.)

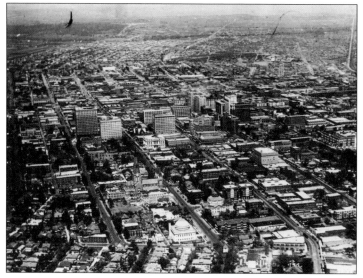

This is a c. 1925 aerial view of downtown Tulsa. The Mayo Hotel had just been completed. Churches visible include First Christian Church, the Christian Science Center, and Holy Family Cathedral. The Greenwood District is to the north. (Courtesy of the Beryl Ford Collection/ Rotary Club of Tulsa, Tulsa City-County Library and Tulsa Historical Society.)

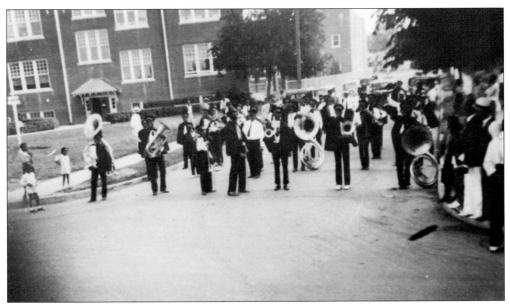

Booker T. Washington High School was, in many ways, the centerpiece of black life in Tulsa. The school, established in 1913, educated many students who became nationally renowned, including Dr. John Hope Franklin, who graduated from Booker T. Washington in 1931. This 1937 photograph shows the Booker T. Washington High School Band. (Courtesy of the Beryl Ford Collection/ Rotary Club of Tulsa, Tulsa City-County Library and Tulsa Historical Society.)

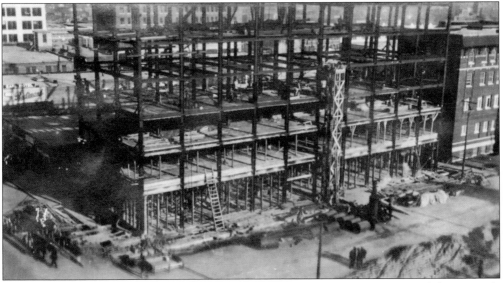

This December 20, 1915, photograph depicts the early phases of construction of the Kennedy Building at 321 South Boston Avenue, built by St. Louis developer S. Gallais. Pioneer Tulsa doctor Samuel Grant Kennedy purchased the structure and tripled its size. He left the word "Gallais" over the south entry. Kennedy was a charter member and the first director of the Commercial Club, a precursor to the Tulsa Chamber of Commerce. He also served on the city council and on bodies that helped to secure railroad service and spearhead the Spavinaw Water Project. Kennedy's signature graces the original charter for the City of Tulsa. (Courtesy of the Beryl Ford Collection/ Rotary Club of Tulsa, Tulsa City-County Library and Historical Society of Tulsa.)

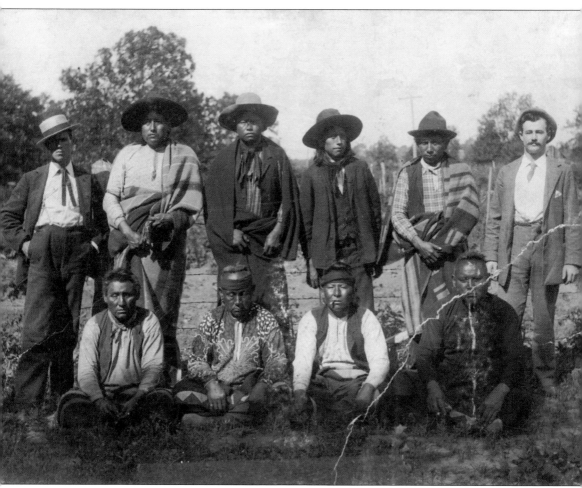

Muscogee (Creek) Indians are seen standing near Main Street and the Frisco Railroad tracks in Tulsa in this c. 1893 photograph. Parts of Tulsa, Indian Territory, lay within the jurisdictional bounds of the Muscogee (Creek) Nation. The Perrymans, a family of Muscogee (Creek) ancestry, are among Tulsa's founding families. (Courtesy of the Beryl Ford Collection/Rotary Club of Tulsa, Tulsa City-County Library and Tulsa Historical Society.)

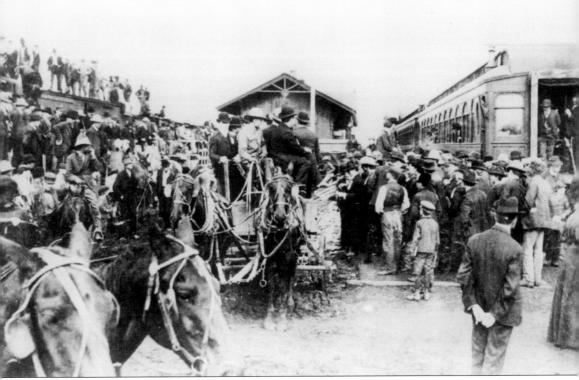

This 1905 view looking east shows the Frisco Depot, located between Boston Avenue and Main Street on the north side of the railroad tracks. (Courtesy of the Beryl Ford Collection/Rotary Club of Tulsa, Tulsa City-County Library and Tulsa Historical Society.)

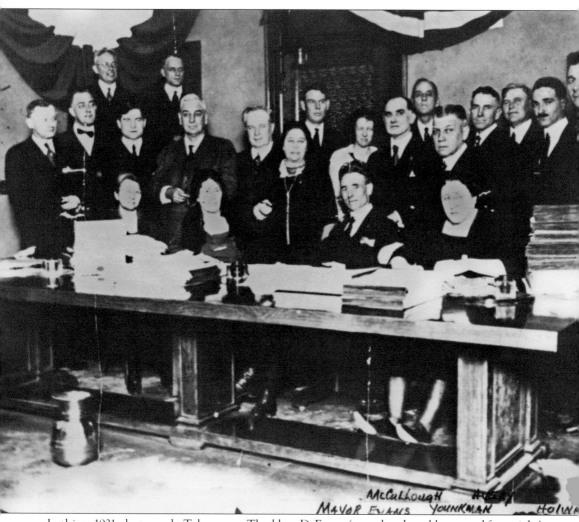

In this c. 1921 photograph, Tulsa mayor Thaddeus D. Evans (seated at the table, second from right) signs bonds to create the Spavinaw Creek Dam. Mayor Evans led Tulsa during one of its more ambitious undertakings, the Spavinaw Water Project. Mayor Evans's administration completed the plans for the project, began purchasing land, created the first water board, and secured the services of General George Goethals, builder of the Panama Canal, as an advisor. Lilah Lindsey, Tulsa civic leader and women's club founder, stands in the middle of the group, while the city clerk is seated next to Mayor Evans. Mayor Evans also presided over Tulsa during its darkest days—the 1921 Tulsa Race Riot that obliterated the African American community and opened a gulf of distrust that has yet to be fully closed. (Courtesy of the Beryl Ford Collection/Rotary Club of Tulsa, Tulsa City-County Library and Tulsa Historical Society.)

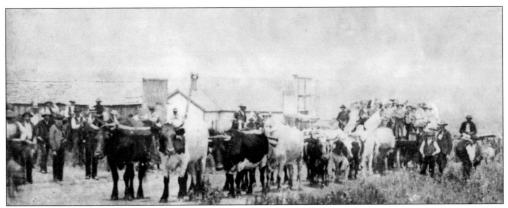

This July 4, 1886, photograph captures the Tulsa, Indian Territory, Fourth of July Parade. In the early 1800s, most of present-day Oklahoma was known as "Indian Territory," home to Plains Indians and the forcibly removed Five Civilized Tribes, which included the Cherokee, Choctaw, Chickasaw, Seminole, and Muscogee (Creek). Around 1890, pre-statehood Oklahoma consisted of the Twin Territories: to the west was Oklahoma Territory; to the east was a substantially diminished, in terms of land mass, Indian Territory. Tulsa became incorporated as a city on January 18, 1898. The oxcart seen here is being driven by the Wimberly family. (Courtesy of the Beryl Ford Collection/Rotary Club of Tulsa, Tulsa City-County Library and Tulsa Historical Society.)

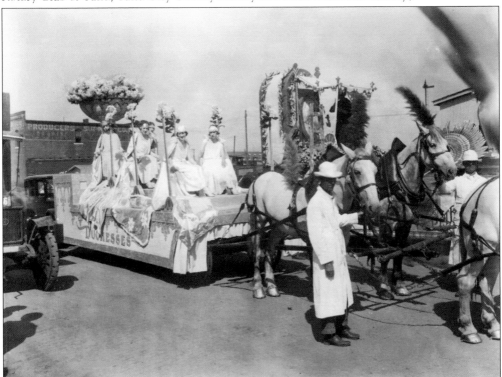

This 1923 photograph captures the celebration of Tulsa's first International Petroleum Exposition, known as the IPE, by way of a parade. The IPE exhibited the latest oil industry technology, provided a venue for oilmen to purchase up-to-date equipment, and educated workers and the public at large about the industry. (Courtesy of the Beryl Ford Collection/Rotary Club of Tulsa, Tulsa City-County Library and Tulsa Historical Society.)

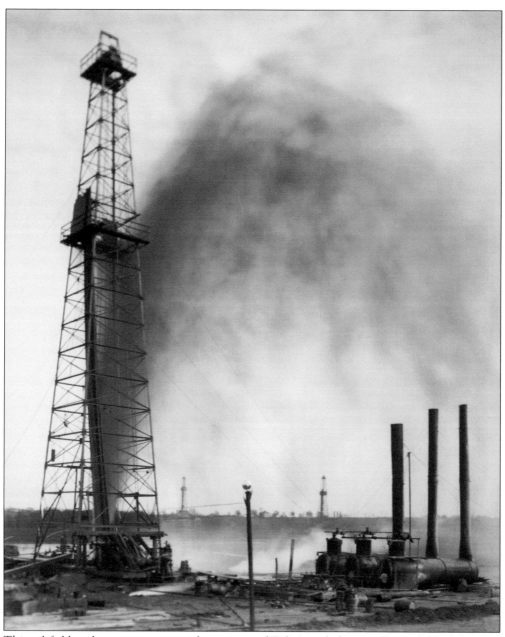

This oil field gusher scene captures the essence of Tulsa's early history. Once dubbed the "Oil Capital of the World," Tulsa's fortunes swelled with the demand for black gold. Scores of oil-related businesses set up shop in the Tulsa area. Immigration followed this economic good fortune. Walter White, assistant secretary of the National Association for the Advancement of Colored People (NAACP), traveled to post-riot Tulsa to conduct damage assessment. White, whose blond hair and blue eyes concealed his African ancestry, managed to go undetected. He published his findings in the June 29, 1921, issue of *The Nation*, noting: "Tulsa is a thriving, bustling, enormously wealthy town of between 90,000 and 100,000. In 1910, it was the home of 18,182 souls, a dead and hopeless outlook ahead. Then oil was discovered. The town grew amazingly." (Courtesy of the Beryl Ford Collection/Rotary Club of Tulsa, Tulsa City-County Library and Tulsa Historical Society.)

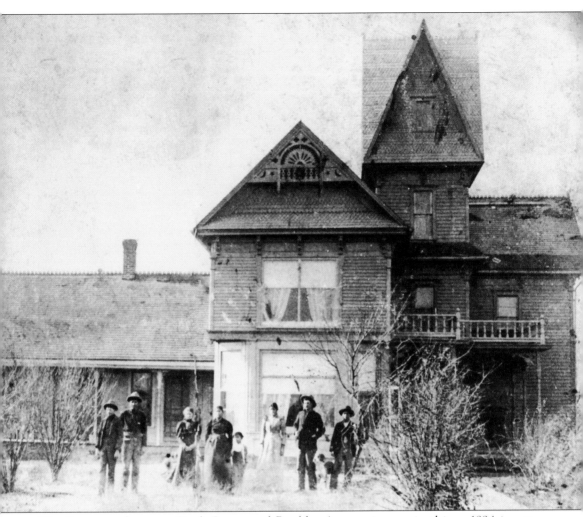

The Perryman home at Sixth Street and Boulder Avenue is seen in this c. 1894 image. The George Perryman family grew as it embraced increasing numbers of orphans. Rachel Perryman subsequently sold the property to Tulsa County for a new courthouse location. She stipulated that the payment be made in gold. Parts of the original residence still exist at a home between Thirteenth and Fourteenth Streets on the east side of Elwood Avenue. (Courtesy of the Beryl Ford Collection/Rotary Club of Tulsa, Tulsa City-County Library and Tulsa Historical Society.)

This is a portrait of Tulsa mayor Thaddeus D. Evans, a Republican elected in 1920 who served until 1922. Mayor Evans, Tulsa's 15th mayor, led the city during the calamitous 1921 Tulsa Race Riot. His administration received acclaim for its work on the city's water system. (Courtesy of the Beryl Ford Collection/Rotary Club of Tulsa, Tulsa City-County Library and Tulsa Historical Society.)

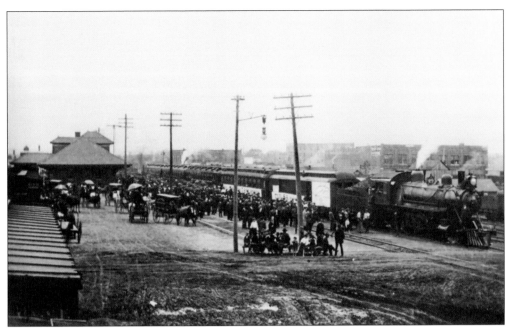

This 1908 image, "Reeder Return of Booster Train," illustrates the widespread excitement for this burgeoning city. By 1908, Tulsa was well on its way to becoming "The Oil Capital of the World." By the time of the 1921 Tulsa Race Riot, it boasted a population of around 100,000. Walter White noted in *The Nation* that "The town has a number of modern office buildings, many beautiful homes, miles of clean, well-paved streets, and aggressive and progressive business men who well exemplify Tulsa's motto of 'The City with a Personality.'" (Courtesy of the Beryl Ford Collection/ Rotary Club of Tulsa, Tulsa City-County Library and Tulsa Historical Society.)

This 1895 photograph shows the Tulsa Market, located on Main Street between First and Second Streets. Note the signage that reads "Cash Paid for Hides" and the nod to the "most famous Indian Territory Deputy Marshal." James Franklin "Bud" Ledbetter (1852–1937) served as deputy sheriff of Johnson County, Arkansas; deputy US marshal of the Oklahoma Territory; and sheriff of Muskogee County, Oklahoma. (Courtesy of the Beryl Ford Collection/ Rotary Club of Tulsa, Tulsa City-County Library and Tulsa Historical Society.)

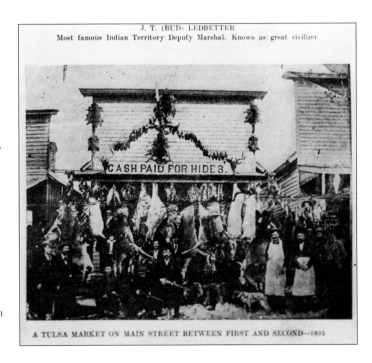

J. T. (BUD) LEDBETTER
Most famous Indian Territory Deputy Marshal. Known as great civilizer

CASH PAID FOR HIDES.

A TULSA MARKET ON MAIN STREET BETWEEN FIRST AND SECOND—1895

This undated photograph is entitled "Working on drilling rig." Oil made many a fortune in Tulsa and fueled the economic explosion that made Tulsa, for a time, the talk of the nation. Tulsa's population swelled to more than 140,000 by 1930. Walter White noted that Tulsa "lies in the center of the oil region and many are the stories told of the making of fabulous fortunes by men who were operating on a shoe-string. Some of the stories rival those of the 'forty-niners' in California." (Courtesy of the Beryl Ford Collection/Rotary Club of Tulsa, Tulsa City-County Library and Tulsa Historical Society.)

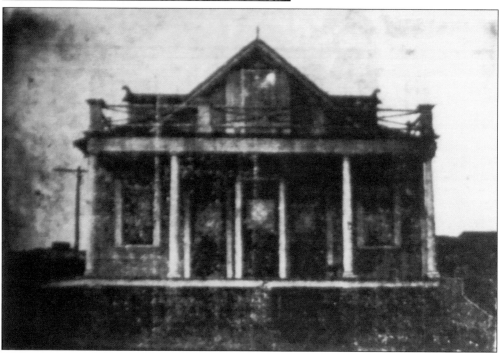

This photograph from the *Tulsa Star*, dated August 19, 1914, shows the residence of Henry T. Wilson, an early Tulsa entrepreneur. Wilson leased out the house while he and his wife operated a hotel and restaurant at 120 East Archer Street. (Courtesy of I. Marc Carlson, Librarian of Special Collections and University Archives, The University of Tulsa.)

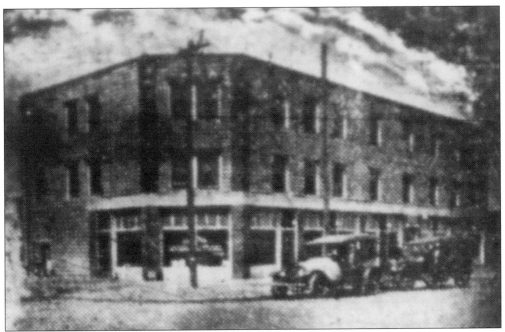

This 1918 image of the Red Wing Hotel, 202–208 North Greenwood Avenue, appeared in a number of advertisements in the *Tulsa Star*. The Red Wing Hotel was destroyed in the 1921 Tulsa Race Riot. (Courtesy of I. Marc Carlson, Librarian of Special Collections and University Archives, The University of Tulsa.)

This undated photograph shows the Tribune Building built in 1924 at 20 East Archer Street. *The Tulsa Tribune*, an afternoon daily newspaper, published a series of articles and editorials that inflamed racial tensions in the Tulsa community both before and immediately after the 1921 Tulsa Race Riot. (Courtesy of the Beryl Ford Collection/ Rotary Club of Tulsa, Tulsa City-County Library and Tulsa Historical Society.)

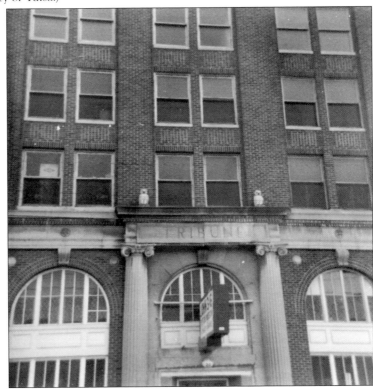

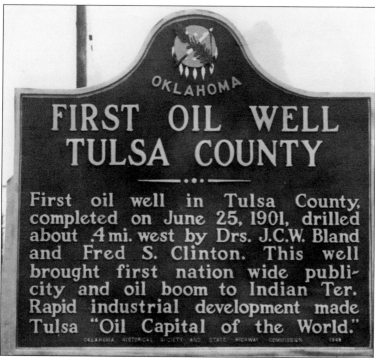

This historical marker describes Tulsa County's first oil well, completed on June 25, 1901, by drillers Dr. John C.W. Bland and Dr. Fred S. Clinton. This alpha well helped catapult Tulsa into the national spotlight. (Courtesy of the Beryl Ford Collection/Rotary Club of Tulsa, Tulsa City-County Library and Tulsa Historical Society.)

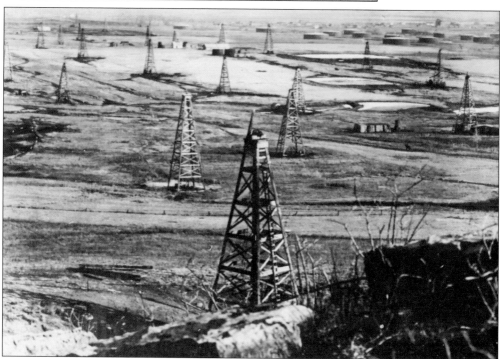

This 1912 photograph of a Tulsa-area oil field, the landscape dotted with oil wells, attests to the importance of oil to early Tulsa history. The crude bubbling beneath the surface fueled fortunes and transformed Tulsa into the "Magic City." (Courtesy of the Beryl Ford Collection/Rotary Club of Tulsa, Tulsa City-County Library and Tulsa Historical Society.)

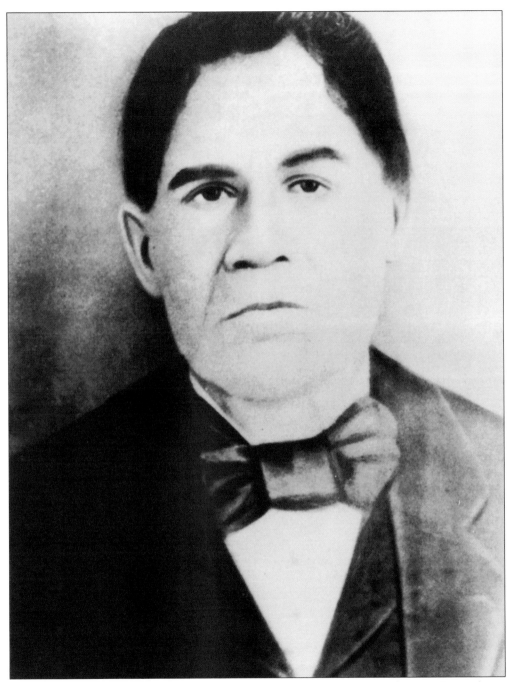

Chief Chilly McIntosh led the first contingent of Muscogee (Creek) Indians to Fort Gibson, Oklahoma, in 1827–1828. He led a scouting party up the Arkansas River and located and marked the site of the Creek Council Oak in 1928 as a ceremonial and ball ground for his fellow emigrants who followed. Some of the Greenwood District pioneers had ties to the Muscogee (Creek) Nation. Much of Tulsa sits in what was once considered "Creek Country." This is a copy of a painting done by John Mix Stanley at Fort Gibson in 1843. (Courtesy of the Beryl Ford Collection/Rotary Club of Tulsa, Tulsa City-County Library and Tulsa Historical Society.)

Shown here is a portrait of the multi-racial Perryman family, which was composed of Muskogee (Creek), African, and Caucasian individuals. The Perryman family was one of Tulsa's founding families. Seen in this image are, from left to right, (first row) Sam Beaver and unidentified; (second row) Spot Childers, George B. Perryman, Moses Perryman, unidentified, and Glen Flippen; (third row) Reuben Partridge, Tom Kinney, unidentified, and Roy West. (Courtesy of the Beryl Ford Collection/Rotary Club of Tulsa, Tulsa City-County Library and Tulsa Historical Society.)

Dr. Andrew C. Jackson, photographed around 1920, ranked among the premiere African American physicians of his day. Educated at the Mayo Clinic, Dr. Jackson's prowess as a surgeon afforded him the rare opportunity to service both black and white patients. A teenage white boy murdered Dr. Jackson after the unarmed physician left his home in surrender during the 1921 Tulsa Race Riot. NAACP Assistant Secretary Walter White reported in *The Nation* that Dr. Jackson had an estimated net worth of $100,000. Moreover, White pointed out that the Mayo brothers described Dr. Jackson as "the most able Negro surgeon in America" and that Dr. Jackson, a solid citizen, earned praise and admiration across racial lines. (Courtesy of the Greenwood Cultural Center.)

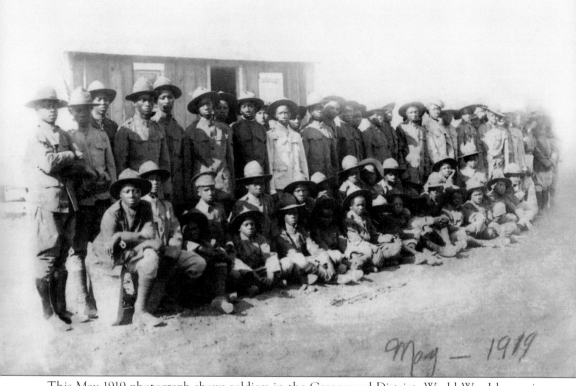

This May 1919 photograph shows soldiers in the Greenwood District. World War I began in Europe in 1914. The United States entered the conflict on April 6, 1917; the war ended in 1918. African American soldiers viewed the war as an opportunity to enhance their social, political, and economic standing in the United States after having fought for their country abroad. They would be sorely disappointed, as the first quarter of the 20th century proved particularly brutal for African Americans. Race riots, lynchings, and civil rights retrenchment proliferated. (Courtesy of the Greenwood Cultural Center.)

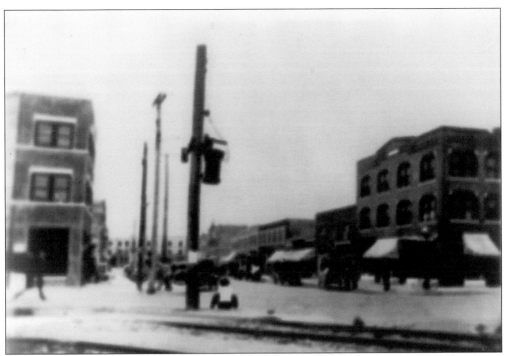

This c. 1920s photograph shows "Deep Greenwood," the 100 block of Greenwood Avenue, looking northeast. All manner of businesses contributed to the vibrancy of this bustling black enclave: milliners, grocery stores, beauty parlors, tailors, movie houses, dance clubs, and more. Walter White noted: "The Negro in Oklahoma has shared in the sudden prosperity that has come to many of his white brothers, and there are some colored men there who are wealthy." (Courtesy of the Greenwood Cultural Center.)

The Williams Dreamland Theater, photographed around 1920, was one of several businesses owned and operated by John and Loula Williams. Other enterprises included a rooming house, a confectionery, and a garage. (Photograph from the 1921 Booker T. Washington High School yearbook, courtesy of Rudisill Regional Library, Tulsa.)

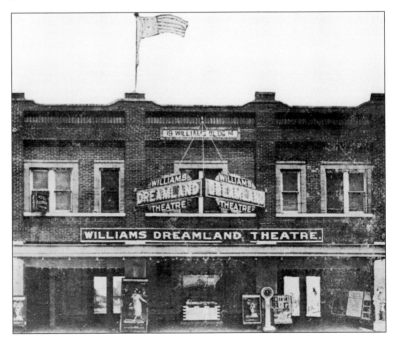

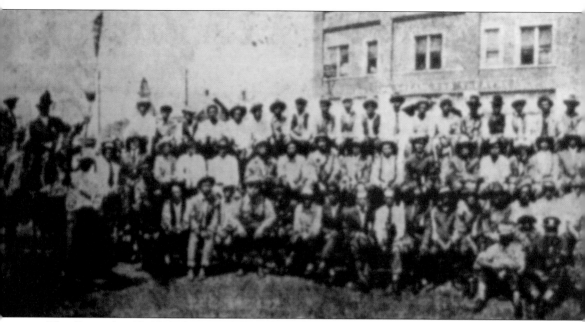

This September 28, 1918, photograph from the *Tulsa Star* entitled "Tulsa Boys Who Are Called by the Government to Do Their Bit" shows a group of young men gathered at the Williams Dreamland Theater. The Dreamland provided proof of the sophistication of this African American community in the early 20th century. The theater showed live musical and theatrical revues as well as silent

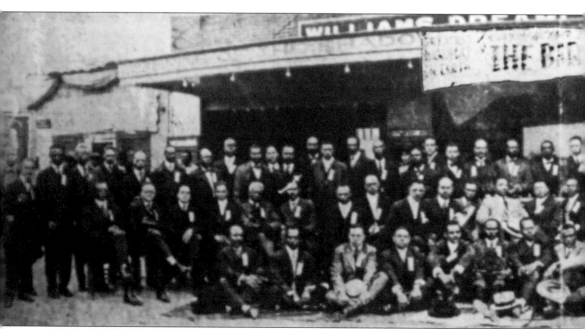

This May 22, 1920, photograph from the *Tulsa Star* entitled "Visitors to the State Medical, Dental, and Pharmaceutical," shows a group of professionals gathered at the Williams Dreamland Theater.

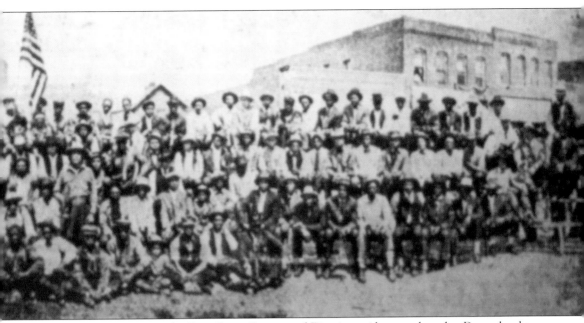

films. During the 1921 Tulsa Race Riot, Greenwood District residents gathered at Dreamland to plan a course of action. In the end, the riotous mob destroyed the Dreamland, together with most of the rest of the "Negro Wall Street." (Courtesy of the Greenwood Cultural Center.)

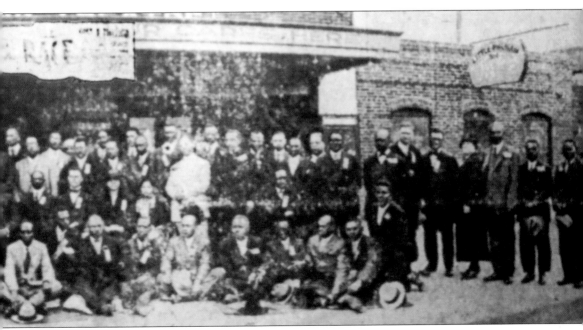

(Courtesy of the Greenwood Cultural Center.)

Foreword

TODAY THE CLASS OF JUNE, 1921, IS ONE
CO-ORDINATE ORGANIZATION. TOMORROW IT
BECOMES EIGHTEEN SEPERATE BITS OF INDI-
VIDUALITY, SWALLOWED UP BY THE GREAT
OUTSIDE LIFE, AND SPREAD POSSIBLY TO THE
FOUR CORNERS OF THE EARTH. FOR THE
MEMORY OF THAT ORGANIZATION, THE FOUR
YEARS SPENT AT BOOKER WASHINGTON HIGH
SCHOOL and THE INTERESTS CENTERED THERE,
THE EXCELSIOR OF JUNE '21 IS WRITTEN.

—THE CLASS

PAGE TWO

The foreword from the 1921 Booker T. Washington High School yearbook reads, "Today the class of June, 1921, is one co-ordinate organization. Tomorrow it becomes eighteen seperate [sic] bits of individuality, swallowed up by the great outside life, and spread possibly to the four corners of the earth. For the memory of that organization, the four years spent at Booker Washington High School and the interests centered there, the excelsior of June '21 is written—The Class." (Photograph from the 1921 Booker T. Washington High School yearbook, courtesy of Rudisill Regional Library, Tulsa.)

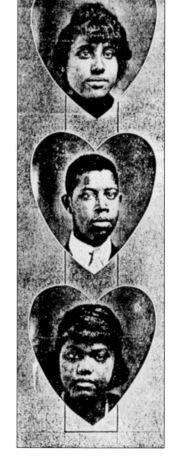

Pictured from top to bottom, Annie L. Goodwin, John I. Claybon, and Mary M. Allison were all members of the graduating class of Booker T. Washington High School in 1921. The yearbook featured short poems to describe each student's personality. The inscription accompanying Mary M. Allison's photograph reads, "She has a smile that's very sweet. / A kindlier girl you seldom meet." (Photograph from the 1921 Booker T. Washington High School yearbook, courtesy of Rudisill Regional Library, Tulsa.)

34

Pearl McCrimmon, Reed Rollerson, and Amanda Robinson, pictured from top to bottom, were all graduates of Booker T. Washington High School's class of 1921. Known for excellence and academic rigor, the high school produced a host of academic and athletic standouts over the course of decades. (Photograph from the 1921 Booker T. Washington High School yearbook, courtesy of Rudisill Regional Library, Tulsa.)

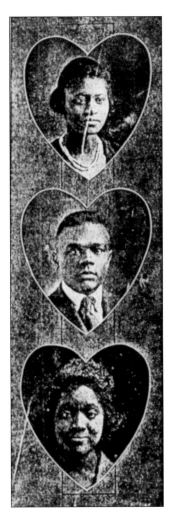

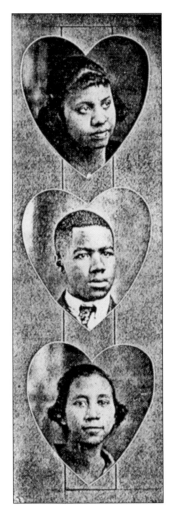

From top to bottom, Esther May Loupe, Phineas W. Thompson, and Celestine Z. Hodnett were members of the graduating class of Booker T. Washington High School in 1921. The poem accompanying Phineas W. Thompson's class portrait reads, "His repartee and ready wit, have with the girls made quite a hit." (Photograph from the 1921 Booker T. Washington High School yearbook, courtesy of Rudisill Regional Library, Tulsa.)

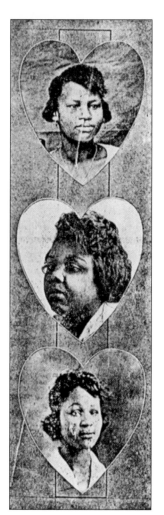

Pictured from top to bottom, Effie Hampton, Ora Lee Young, and Janniva Brown were graduates of Booker T. Washington High School. Next to Effie's picture, a poem described her promise: "Though small of stature, yet large of heart, / We find in her a unique art, / Which cultured right may make her life full of success, joy and light." (Photograph from the 1921 Booker T. Washington High School yearbook, courtesy of Rudisill Regional Library, Tulsa.)

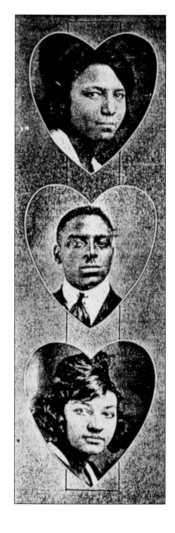

Pictured from top to bottom, Dora Hogan, Bennie Tolbert, and Beatrice Johns, graduates of the 1921 class at Booker T. Washington High School. Next to Dora's picture, a verse declares: "Enthusiastic, energetic, full of pep and life, She will surely make some one a very sweet wife." (Photograph from the 1921 Booker T. Washington High School yearbook, courtesy of Rudisill Regional Library, Tulsa.)

Pictured from top to bottom, Irene Simpson, Edward Goodwin, and Beatrice Pratt were graduates of Booker T. Washington High School in 1921. A poem next to Beatrice's class portrait described her demeanor by saying, "A very sunshiny young Miss is she, / Who's always as happy as can be." (Photograph from the 1921 Booker T. Washington High School yearbook, courtesy of Rudisill Regional Library, Tulsa.)

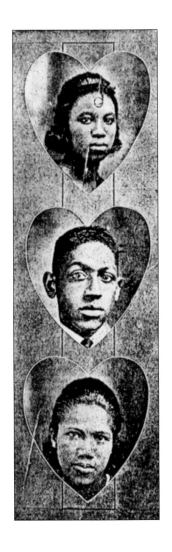

The featured ads from the 1921 Booker T. Washington High School yearbook illustrate the community's involvement in and support of the local school. (Photograph from the 1921 Booker T. Washington High School yearbook, courtesy of Rudisill Regional Library, Tulsa.)

This image features ads from the 1921 Booker T. Washington High School yearbook. Community recognition of and support for the school has always been strong and continues to be so today. (Photograph from the 1921 Booker T. Washington High School yearbook, courtesy of Rudisill Regional Library, Tulsa.)

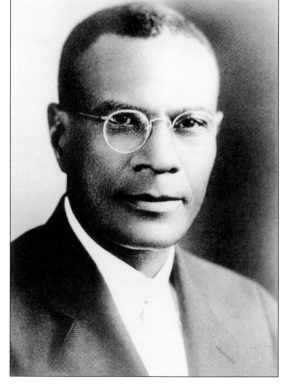

This is an undated photograph of Ellis Walker Woods, the famed principal of Tulsa's Booker T. Washington High School. Woods's 1948 memorial services were held at the Tulsa convention center, one of the few venues large enough to accommodate the mourners who longed to say their last goodbye to E.W. Woods, fondly dubbed "the quintessential Tulsan" by local media. (Photograph courtesy of the *Tulsa World*.)

Two

RIOT

History, despite its wrenching pain, cannot be unlived,
but if faced with courage, need not be lived again.

—Dr. Maya Angelou

In a 16-hour eruption of volcanic violence called the 1921 Tulsa Race Riot, marauding white hooligans set upon the Greenwood District. Planes circled about. While official reports cast the flyovers as mere reconnaissance missions, some eyewitnesses reported seeing the planes drop incendiary devices—bombs—on the already shell-shocked area.

The scorched earth assault on the Greenwood District left little unscathed: homes and businesses reduced to charred rubble; scores dead, dying, and wounded; and hundreds homeless and destitute. Some African Americans fled Tulsa, never to return. The riot remains the worst of the many instances of mass violence against African Americans that marred the national landscape in the early 20th century. The breadth and brutality of it all etched psychic scars still palpable today.

The riot dimmed Tulsa's luster and threatened her reputation as America's economic darling. What happened, or, perhaps more consequentially, what failed to happen, in its wake shaped race relations in Tulsa for decades after.

Until the late 20th century, the catastrophic riot remained shrouded in mystery, cloaked in secrecy, and draped in conjecture. Despite its significance as a defining moment in the history of the city, state, and nation, some Tulsans, even more Oklahomans, and most Americans, remain largely oblivious to this watershed event.

The 1997 convening of the Oklahoma Commission to Study the Tulsa Race Riot of 1921 shined a spotlight on the incident. The commission's deliberations and its 2001 final report generated enormous press coverage and reignited community interest.

The full cost of Tulsa's reluctant reckoning has yet to be calculated. Perhaps the greatest casualty—trust—has yet to be fully recouped. Recent examples of such trust issues include a 1990s lawsuit by black police officers against the City of Tulsa alleging racial discrimination (settled in 2010) and a 2013 controversy over a popular arts and entertainment area near downtown named for a Tulsa pioneer recently revealed to have had ties to the KKK and possibly the riot as well. The once vast chasm of distrust between black and white still lingers, marginally diminished, but no less real.

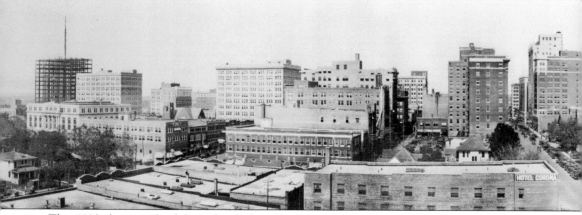

This 1923 photograph of the Tulsa skyline illustrates the city's remarkable economic trajectory just 25 years after incorporation. Walter White noted: "One could travel far and find few cities where the likelihood of trouble between the races was as little thought of as in Tulsa. Her reign of

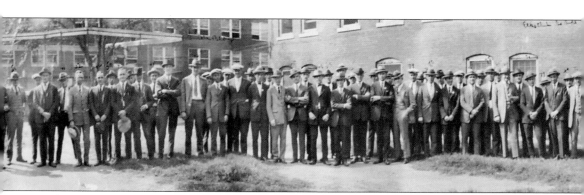

This 1923 photograph of the Tulsa Junior Chamber (the "Jaycees") showcases Tulsa's young establishment leaders. Founded on January 21, 1920, the Jaycees provide opportunities for young men between the ages of 18 and 41 to develop personal and leadership skills through service to others. At the time of this photograph, the Jaycees offered such opportunities only to young white men. During this era, referred to by many as the nadir of race relations in America,

terror stands as a grim reminder of the grip mob violence has on the throat of America, and the ever-present possibility of devastating race conflicts where least expected." (Courtesy of the Beryl Ford Collection/Rotary Club of Tulsa, Tulsa City-County Library and Tulsa Historical Society.)

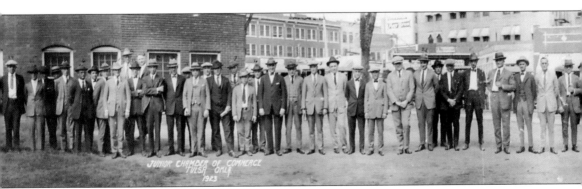

white supremacy reigned and membership in domestic terroristic organizations like the KKK swelled. The 1920s rolls of the Tulsa KKK include the names of a number of well-heeled citizens. (Courtesy of the Beryl Ford Collection/Rotary Club of Tulsa, Tulsa City-County Library and Tulsa Historical Society.)

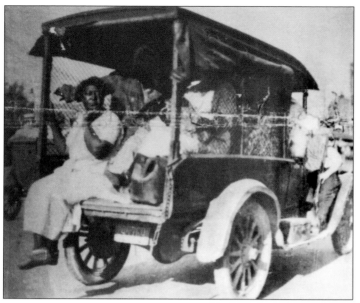

This photograph of a forlorn black woman and others fleeing the carnage of the 1921 Tulsa Race Riot is captioned, "Homeless negroes gathered by the militia and citizen deputies and taken to the hastily constructed shelters at the Fair Grounds, where they were cared for by the Red Cross and other agencies." (Courtesy of the Beryl Ford Collection/Rotary Club of Tulsa, Tulsa City-County Library and Tulsa Historical Society.)

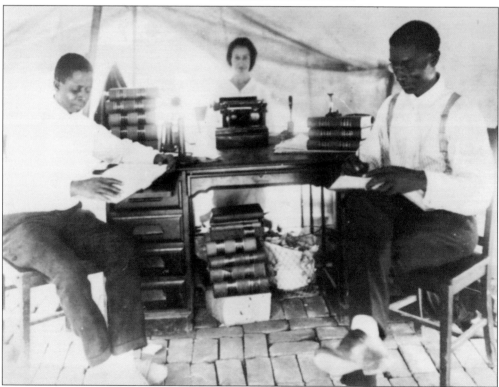

Attorney Buck Colbert Franklin, right, works with colleagues in a makeshift law office to assist victims of the riot with legal claims. Franklin won a critical court decision that struck down a city ordinance that would have imposed strict rebuilding requirements in the wake of the riot. These new provisions would have made reconstruction cost-prohibitive for many African Americans. Franklin is the father of the late eminent historian, Dr. John Hope Franklin. (Courtesy of the Beryl Ford Collection/Rotary Club of Tulsa, Tulsa City-County Library and Tulsa Historical Society.)

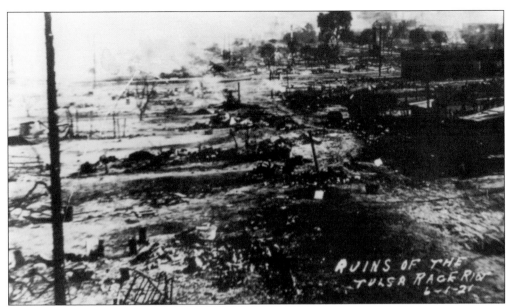

This photograph, labeled "Ruins of the Tulsa Race Riot, 6–1–21," captures the devastation wrought by the worst of the 20th century American race riots. Many believe the historical referent "race riot" misses the mark for these widespread incidents of racial violence. The Tulsa event, for example, has alternately been called an assault, a burning, a holocaust, a catastrophe, a sacking, a lynching, a pogrom, an eruption, an ethnic cleansing, and a massacre. (Courtesy of the Beryl Ford Collection/Rotary Club of Tulsa, Tulsa City-County Library and Tulsa Historical Society.)

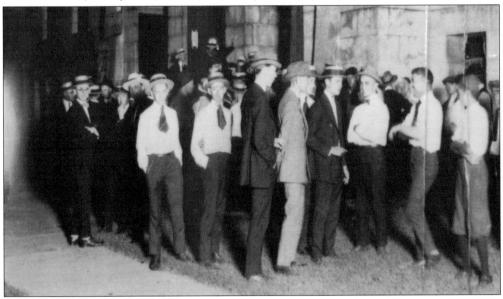

A group of professionally attired white men gather in downtown Tulsa as the riot unfolds. The next few hours would thrust Tulsa into the national spotlight for all the wrong reasons. Walter White suggested in *The Nation* that some whites "feel that these [wealthy] colored men, members of an 'inferior race,' are exceedingly presumptuous in achieving greater economic prosperity than they who are members of a divinely ordered superior race." (Courtesy of the Beryl Ford Collection/ Rotary Club of Tulsa, Tulsa City-County Library and Tulsa Historical Society.)

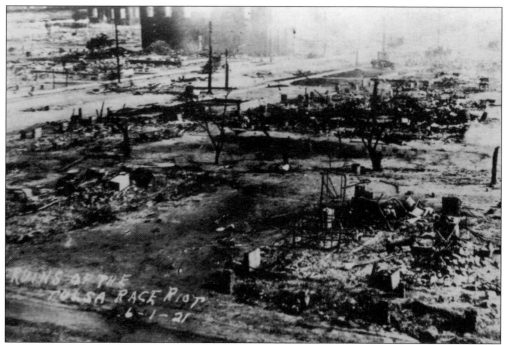

This photograph, also labeled "Ruins of the Tulsa Race Riot, 6–1–21," further illustrates the magnitude of the destruction. Taken from the roof of Booker T. Washington High School, the image shows Dunbar Elementary School at left rear. (Courtesy of the Beryl Ford Collection/ Rotary Club of Tulsa, Tulsa City-County Library and Tulsa Historical Society.)

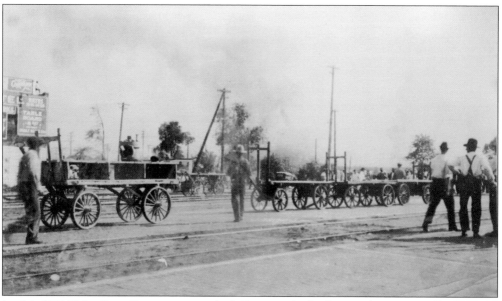

In this 1921 Tulsa Race Riot scene, smoke billows in the background as men walk along the railroad tracks. The riot caused massive physical damage and left profound emotional scars on the Tulsa community. (Courtesy of the Beryl Ford Collection/Rotary Club of Tulsa, Tulsa City-County Library and Tulsa Historical Society.)

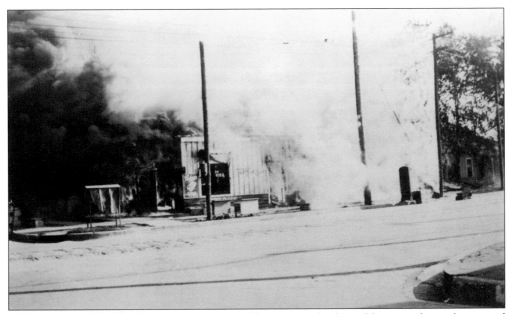

Suffocating smoke fills the air in this scene. The riot resulted in a blazing inferno that wiped out the successful black entrepreneurial enclave known as the "Negro Wall Street." (Courtesy of the Beryl Ford Collection/Rotary Club of Tulsa, Tulsa City-County Library and Tulsa Historical Society.)

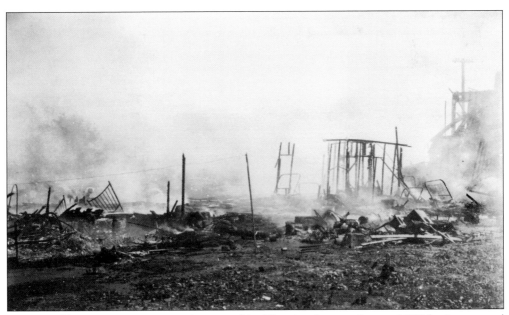

Here, smoldering ruins appear ready to tumble. The riot destroyed some 1,250 businesses and homes, with property damage conservatively estimated in the $1.5–$2 million range in 1921 dollars. (Courtesy of the Beryl Ford Collection/Rotary Club of Tulsa, Tulsa City-County Library and Tulsa Historical Society.)

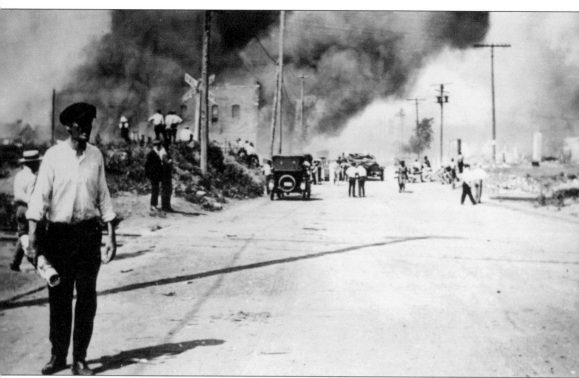

As smoke wafts from the Greenwood District, groups of white men observe the spectacle. (Courtesy of the Beryl Ford Collection/Rotary Club of Tulsa, Tulsa City-County Library and Tulsa Historical Society.)

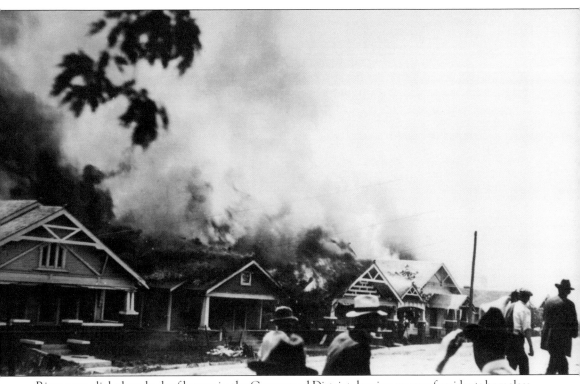

Rioters set alight hundreds of homes in the Greenwood District, leaving scores of residents homeless. The 1921 Tulsa Directory lists the homeowners on this burning block: 521 North Detroit Avenue, P.S. Thompson; 523 North Detroit Avenue, Dr. Andrew C. Jackson; 529 North Detroit Avenue, H.M. Magill; 531 North Detroit Avenue, Ellis Walker Woods; 537 North Detroit Avenue, Thomas R. Gentry; and 541 North Detroit Avenue, C.D. Brown. (Courtesy of the Beryl Ford Collection/ Rotary Club of Tulsa, Tulsa City-County Library and Tulsa Historical Society.)

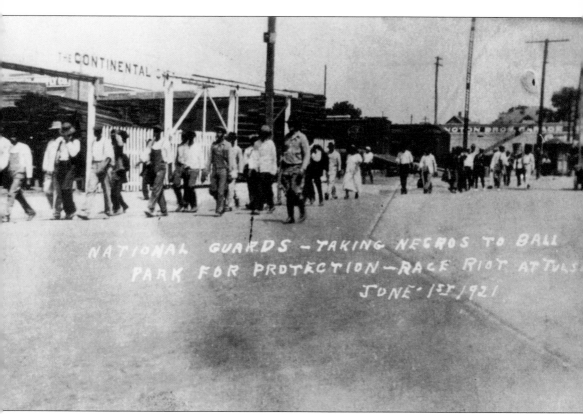

During the 1921 Tulsa Race Riot, black men in Tulsa were interned, ostensibly for their own protection. This internment photograph, marked "National guards—taking Negros to ball park for protection—race riot at Tulsa, June 1st 1921," conjures up images of the internment of Japanese Americans during World War II. Some survivors of the riot noted that the roundup essentially left the Greenwood District defenseless, peopled only by women and children. (Courtesy of the Beryl Ford Collection/Rotary Club of Tulsa, Tulsa City-County Library and Tulsa Historical Society.)

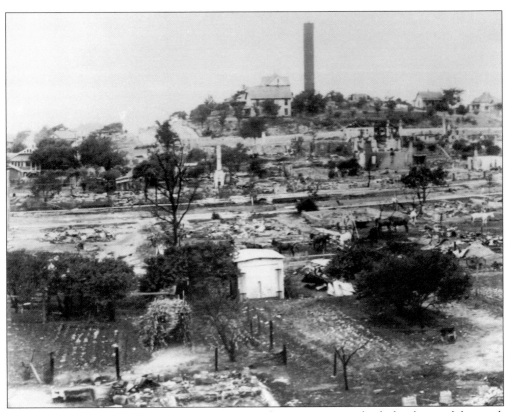

In the wake of the riot, the obliterated Greenwood District appears both desolate and deserted. Walter White discussed how the over-matched African American community rose up to protect one of its own: "Dick Rowland was only an ordinary bootblack with no standing in the community. But when his life was threatened by a mob of whites, every one of the 15,000 Negroes of Tulsa, rich and poor, educated and illiterate, was willing to die to protect Dick Rowland." (Courtesy of the Beryl Ford Collection/Rotary Club of Tulsa, Tulsa City-County Library and Tulsa Historical Society.)

This photograph captures some of the marauding white men who, during the course of the riot, ran roughshod through the Greenwood District. Fire-starters and trigger-happy scofflaws terrorized the black community for hours. (Courtesy of the Beryl Ford Collection/ Rotary Club of Tulsa, Tulsa City-County Library and Tulsa Historical Society.)

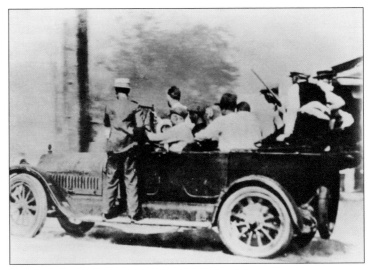

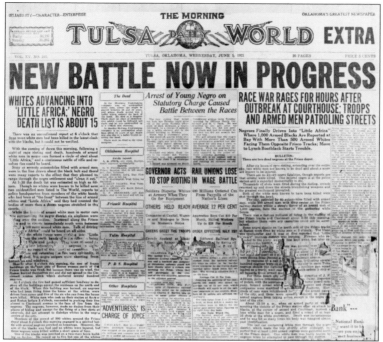

The front page of the June 1, 1921, *Tulsa World* blared headlines describing the progress of the riot, with accounts of whites advancing into "Little Africa" and troops and armed men patrolling the streets. (Courtesy of the Beryl Ford Collection/Rotary Club of Tulsa, Tulsa City-County Library and Tulsa Historical Society.)

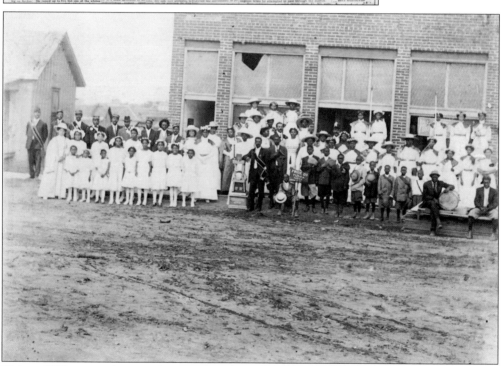

This c. 1923 group photograph was taken from the Frisco Railroad tracks at Boston Avenue in Tulsa's Greenwood District. The dramatic and rapid post-riot rebuilding of the Greenwood District in the face of seemingly insurmountable odds speaks to the human spirit of Tulsa's early African American pioneers. (Courtesy of the Beryl Ford Collection/Rotary Club of Tulsa, Tulsa City-County Library and Tulsa Historical Society.)

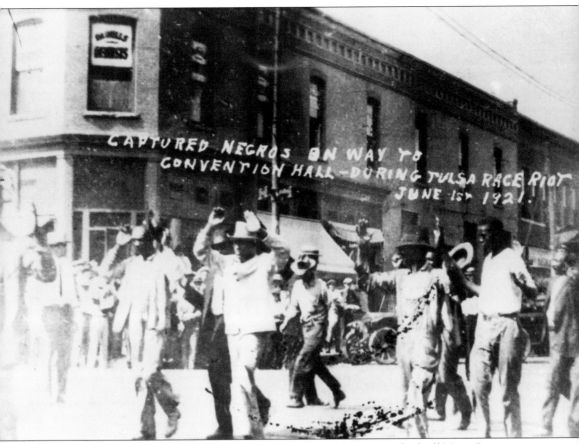

This June 1, 1921, photograph shows captured black men being marched off Main Street onto Second Street in downtown Tulsa, hands up in surrender, to one of the several internment centers throughout Tulsa. The photograph's handwritten caption reads, "Captured Negros on way to Convention Hall during Tulsa Race Riot, June 1st 1921." (Courtesy of the Beryl Ford Collection/Rotary Club of Tulsa, Tulsa City-County Library and Tulsa Historical Society.)

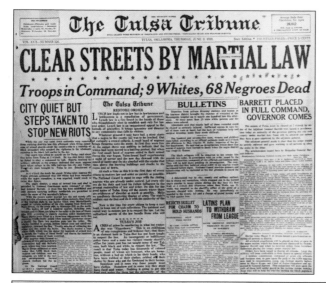

The June 1, 1921, headline of Tulsa's afternoon daily newspaper, *The Tulsa Tribune*, announced the declaration of martial law in Tulsa. The paper also included front-page stories informing Tulsans of post-riot measures designed to quell lingering hostilities. The *Tribune* published a series of inflammatory articles and editorials before and after the riot. One editorial, an alleged pre-riot incitement to lynching, remains missing to this day. (Courtesy of the Beryl Ford Collection/Rotary Club of Tulsa, Tulsa City-County Library and Tulsa Historical Society.)

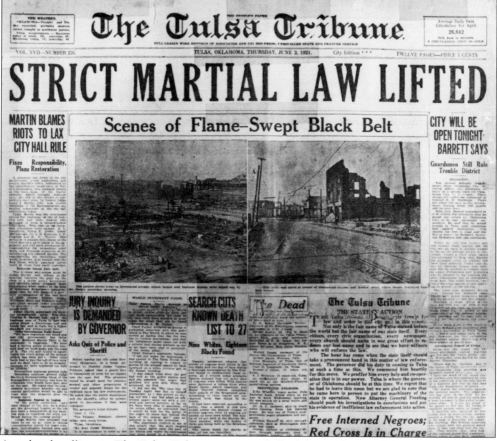

Another headline in *The Tulsa Tribune* trumpeted the lifting of martial law. The paper also included front page stories apportioning blame for the riot and touting post-riot relief measures. (Courtesy of the Beryl Ford Collection/Rotary Club of Tulsa, Tulsa City-County Library and Tulsa Historical Society.)

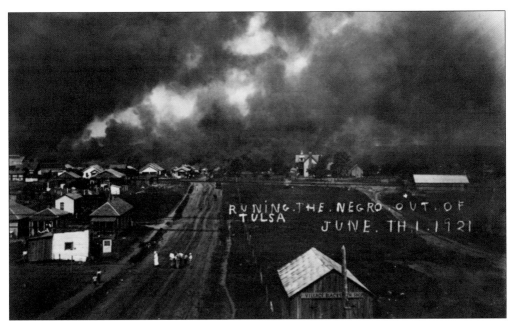

This photograph depicts the smoke-filled sky over the Greenwood District. The telling caption suggests a pogrom. (Courtesy of the Beryl Ford Collection/Rotary Club of Tulsa, Tulsa City-County Library and Tulsa Historical Society.)

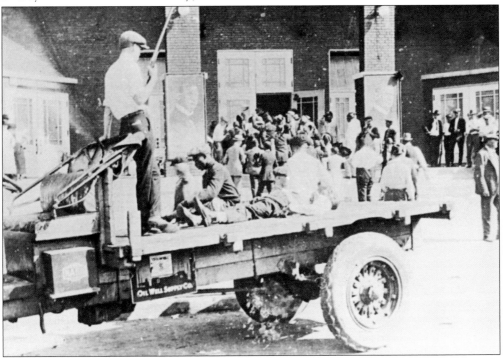

A young armed white man stands atop a flatbed truck, surveying his cargo: a wounded—likely dead—man. A crowd mills about in the background in front of the Tulsa Convention Center (now the Brady Theater). (Courtesy of the Beryl Ford Collection/Rotary Club of Tulsa, Tulsa City-County Library and Tulsa Historical Society.)

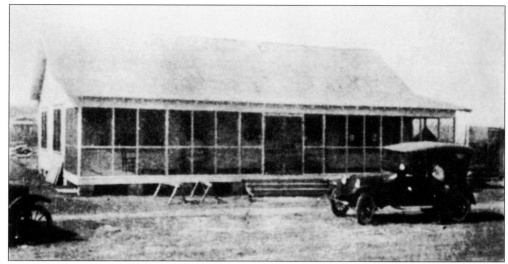

Maurice Willows came to Tulsa from St. Louis to manage the American Red Cross's post-riot relief effort. This building was the headquarters for his operation and was known as the Maurice Willows Hospital. These "Angels of Mercy" did a splendid job by all accounts. (Courtesy of the Beryl Ford Collection/Rotary Club of Tulsa, Tulsa City-County Library and Tulsa Historical Society.)

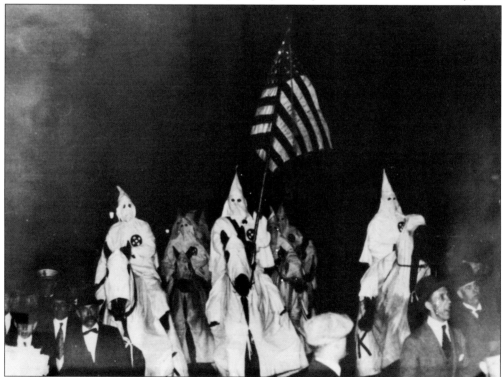

The KKK, a white supremacist hate group, taunted and terrorized African Americans not just in the Deep South, but in places like Oklahoma as well. The KKK gained an incredible foothold in Tulsa and in the state of Oklahoma during the 1920s, with Tulsa boasting a women's auxiliary and youth chapter. (Courtesy of the Beryl Ford Collection/Rotary Club of Tulsa, Tulsa City-County Library and Tulsa Historical Society.)

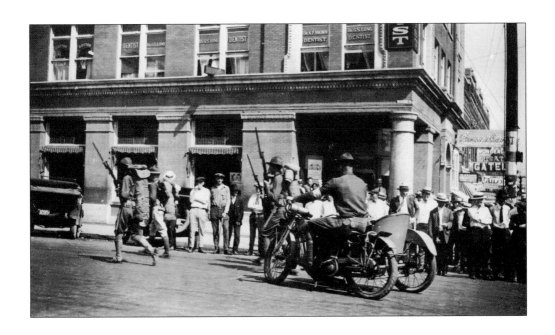

These images show downtown Tulsa during the 1921 Tulsa Race Riot. The riot took place just to the north and east, across the Frisco Railroad tracks from the heart of downtown. Geographically, the riot-ravaged Greenwood District is bounded by Detroit Avenue to the west, the Midland Valley Railroad tracks to the east, Archer Street to the south, and Pine Street to the north. (Both, courtesy of Dana Birkes.)

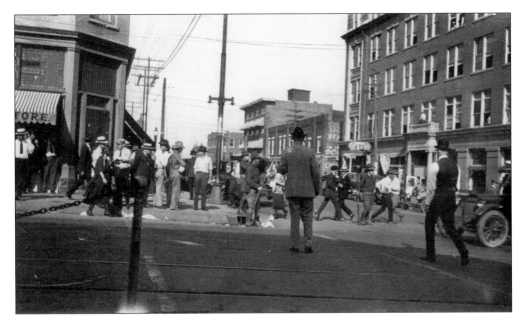

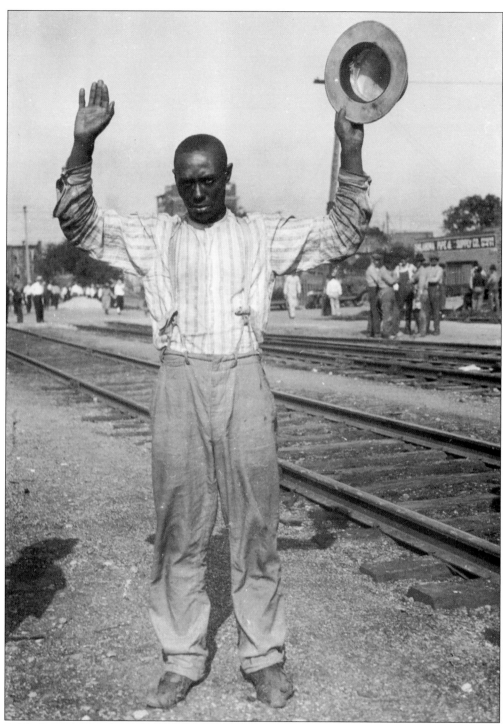

A black man raises his arms in surrender by the Frisco Railroad tracks near Detroit Avenue. Thousands of black men were interned throughout the city as the riot wound down. As a condition of their release, they were given green cards—also known as American Red Cross Refugee Cards—to be signed by a white person willing to vouch for them. (Courtesy of Dana Birkes.)

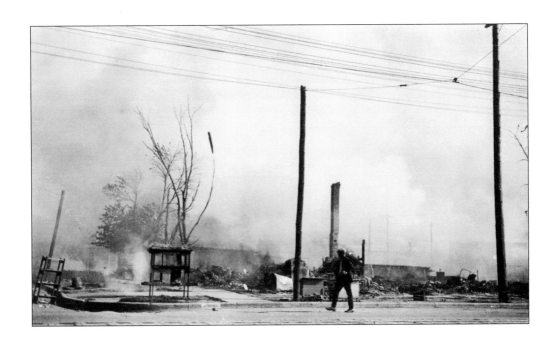

Smoke indicates that all is not well in the Greenwood District. (Both, courtesy of Dana Birkes.)

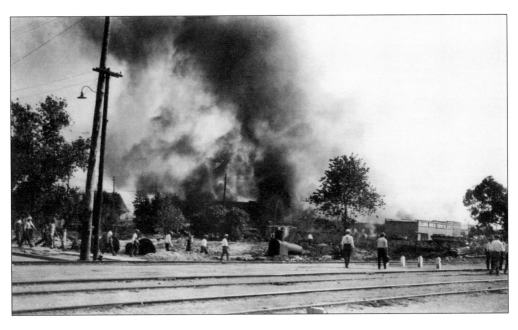

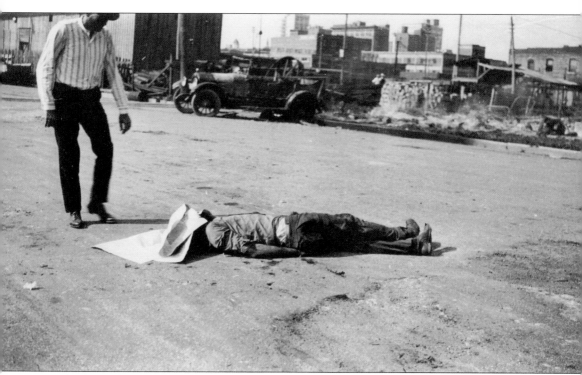

A dead man lies on the road somewhere north of Archer Street. He was one of an estimated 100 to 300 deaths attributable to the unspeakable violence that characterized the 1921 Tulsa Race Riot. Determining a definitive number of deaths has proven virtually impossible. Gaps in records, the possibility of mortally wounded persons fleeing Tulsa and succumbing to their injuries elsewhere, and the oft-repeated prospect of undiscovered mass graves makes it particularly challenging. (Courtesy of Dana Birkes.)

An unidentified gun-toting white man stands defiantly. White men looted downtown pawnshops for guns and ammunition before invading the Greenwood District. Some shopkeepers complied with the looters' demands; those who resisted had their inventories forcibly removed. (Courtesy of Dana Birkes.)

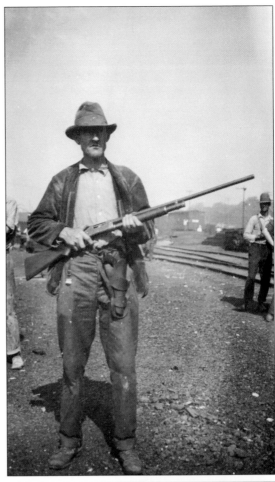

Residents of the Greenwood District, including a woman and child, seek refuge from the carnage and chaos. Many African American families left homeless by the riot spent days, weeks, months, and even years in makeshift tent cities and other irregular housing set up by the American Red Cross. Tulsa's weather extremes, from sweltering summer heat to bitter winter cold, added to the challenges of this already-daunting experience. The riot destroyed at least 1,250 residential and commercial structures in the Greenwood District. (Courtesy of Dana Birkes.)

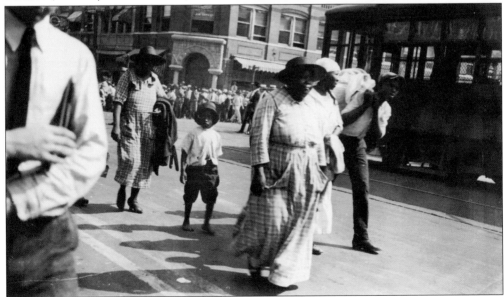

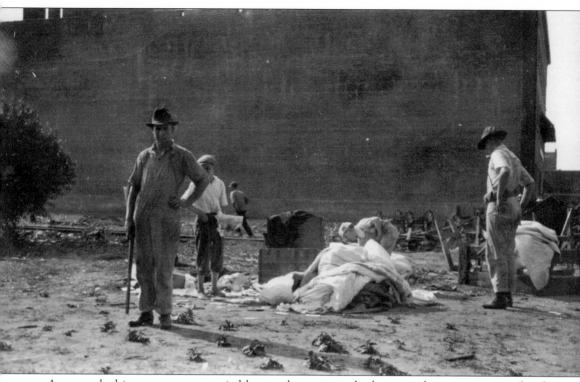

An armed white man, accompanied by another man and a boy, stands sentry over a pile of unknown contents near the railroad tracks. (Courtesy of Dana Birkes.)

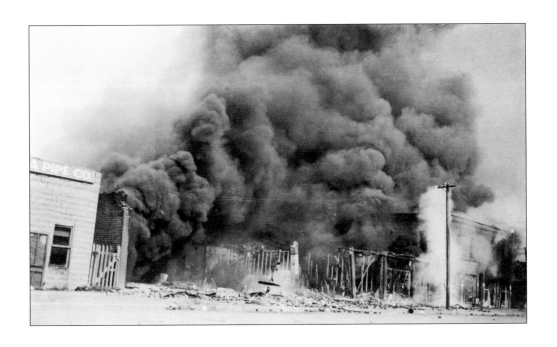

Acrid smoke emanates from the Greenwood District as arsonists' fires burn out of control. The obliteration of the Greenwood District left hundreds of structures in ruins. The monetary value of the still-apparent psychic scars left by the riot is both immeasurable and incalculable. (Both, courtesy of Dana Birkes.)

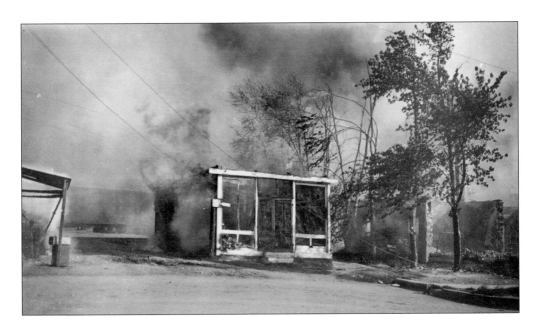

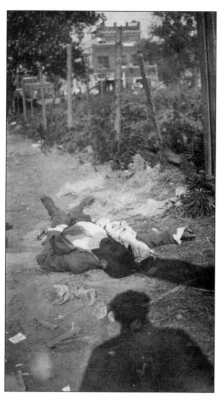

An observer stands over one of the many lifeless bodies that dotted the Greenwood District during and after the riot. Though the precise death count remains indeterminate, most experts believe the total to be somewhere between 100 and 300. Speculation about possible mass graves still persists, with possible locations including Newblock Park, Booker T. Washington Cemetery, and Oaklawn Cemetery. Based on available evidence, the most likely location is Oaklawn Cemetery at Eleventh Street and Peoria Avenue, near downtown Tulsa. (Courtesy of Dana Birkes.)

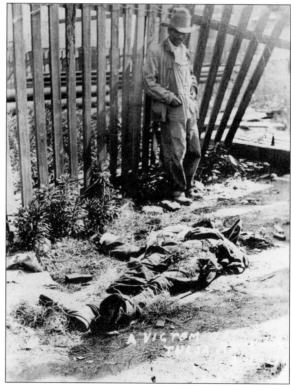

This scene captures the inhumanity of death and the perplexity of life. The riot, though a devastating blow, failed to knock out Tulsa's African American community. (Courtesy of the Greenwood Cultural Center.)

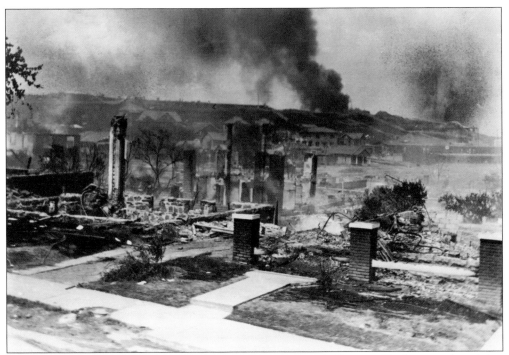

Smoke pours from R.T. Bridgewater's home at 507 North Detroit Avenue. To the immediate left is the home of *Tulsa Star* publisher, A.J. Smitherman. The riotous mob prevented Tulsa firefighters from extinguishing the flames that ultimately consumed the Greenwood District. (Courtesy of the Greenwood Cultural Center.)

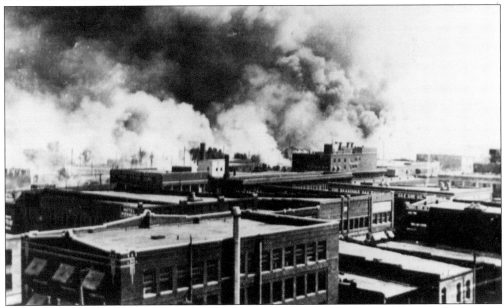

As seen from the roof of Hotel Tulsa, clouds of thick smoke swirl in the air above the Greenwood District inferno. In the end, little would be salvaged and lives would be forever altered. Remarkably, the Greenwood District would be rebuilt, bigger and better than ever, peaking in the 1940s. (Courtesy of the Greenwood Cultural Center.)

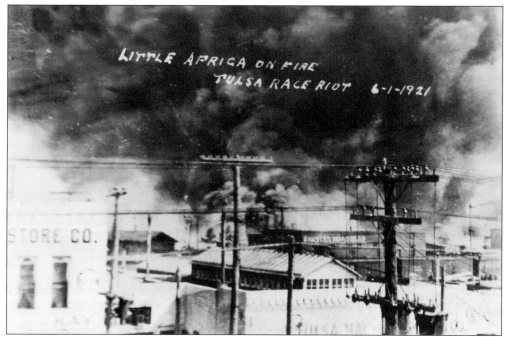

This photograph was taken from the roof of the Sante Fe Depot on First and Elgin Streets. Some white Tulsans referred to the Greenwood District as "Little Africa," a clear racial reference, while others unabashedly resorted to the epithet "Niggertown" to describe Tulsa's African American community. (Courtesy of the Greenwood Cultural Center.)

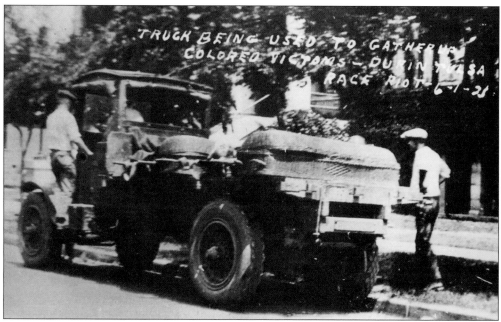

This photograph reads, "Truck being used to gather up Colored victims—during Tulsa Race Riot—6–1–21." In context, "Colored" seems to have been intended as a polite reference to African Americans. (Courtesy of the Greenwood Cultural Center.)

Three

REGENERATION

*A small body of determined spirits fired by an unquenchable
faith in their mission can alter the course of history.*
— Mohandas "Mahatma" Gandhi

The Greenwood District trailblazers rebuilt their community from its smoldering ashes. The community rose up from riot ruins not through magic or miracle, but simply by the blood, sweat, and tears of those for whom it was home.

Rampant land speculation, proposed zoning changes, and failed local leadership could not quell the spirit of Tulsa's African American citizens. The American Red Cross, led by Maurice Willows, supervised the post-riot relief effort. Red Cross workers supplied food, shelter, clothing, and medical care.

Attorney Buck Colbert Franklin and his law partners lodged claims against the City of Tulsa and insurance companies for damage occasioned by the riot. They lobbied nationwide for assistance from African Americans citizens. Operating out of a tent after having lost their offices in the riot, these attorneys doubled as counselors, providing listening ears in addition to legal services.

In short order, the Greenwood District came alive once again, bigger and better than ever. Greenwood Avenue regained her vaunted status as America's "Negro Wall Street." By 1942, scores of businesses called the Greenwood District home once again, a tribute to the triumph of a determined community. That successful post-riot rebound gave way to decline in the 1960s and 1970s. Integration, urban renewal, changing economic conditions, and the lack of business mentoring all played a part in the erosion of this once-prominent entrepreneurial enclave.

In the early 1970s, Tulsa leaders began efforts to re-stitch the unraveling fabric of the Greenwood District. The Greenwood Cultural Center, begun in 1983, became the centerpiece of this community re-imagining. It soon evolved into more than a mere venue, taking on important programmatic leadership, particularly in the areas of educational and cultural experiences, intercultural exchanges, and cultural tourism.

The Greenwood District now sits poised for a renaissance, not necessarily of African American entrepreneurship, but of the human spirit. The community has begun its transformation into an arts, educational, cultural, and entertainment hub.

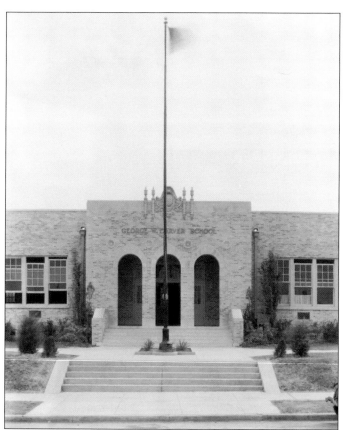

George Washington Carver School, pictured here around 1935, was formerly an all-black institution. The school, named for the famed American scientist, botanist, educator, and inventor, was founded in 1928. It sits between North Hartford Avenue and North Greenwood Avenue, just south of East Pine Street. Today, Carver Middle School is an academic magnet school that follows the Middle Years Program (International Baccalaureate) framework. Students apply for admission and are screened by a selection committee. Selections are based on grades, test scores, attendance, behavior, and teacher recommendations. (Courtesy of the Beryl Ford Collection/Rotary Club of Tulsa, Tulsa City-County Library and Tulsa Historical Society.)

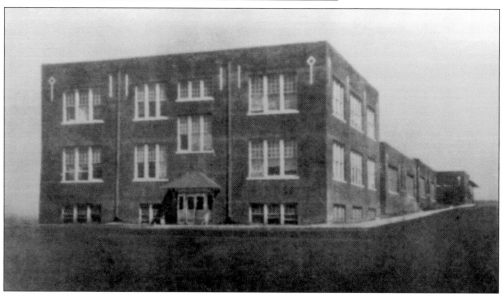

Tulsa's leading black educational institution in 1921, Booker T. Washington High School earned a reputation for high-caliber teaching, academic rigor, and standards of excellence for its students. (Photograph from the 1921 Booker T. Washington High School yearbook, courtesy of Rudisill Regional Library, Tulsa.)

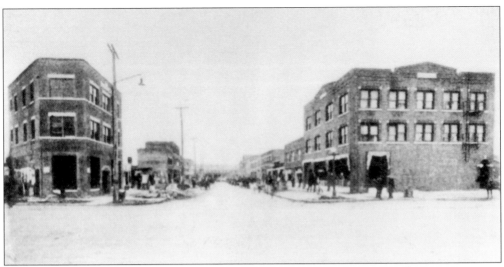

This c. 1940 photograph, looking north from Archer Street down Greenwood Avenue, captures the heart of Tulsa's historic Greenwood District. (Courtesy of the Beryl Ford Collection/Rotary Club of Tulsa, Tulsa City-County Library and Tulsa Historical Society.)

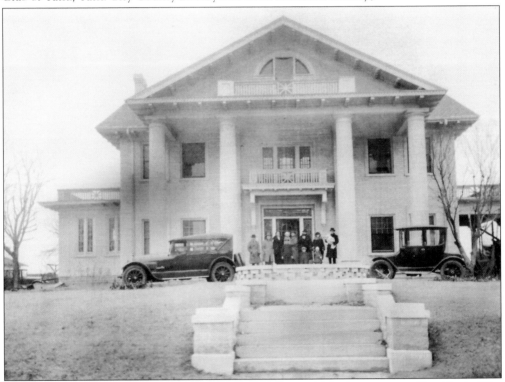

The Brady Mansion, seen here in the 1920s, was home to Tulsa businessman Tate Brady. The home still stands at 620 North Denver Avenue. Brady has become a somewhat controversial figure after the discovery (or perhaps rediscovery) of his possible ties to the KKK and involvement in the 1921 Tulsa Race Riot. Adding to the controversy, a now-booming arts and entertainment district in Tulsa bears the Brady name. (Courtesy of the Beryl Ford Collection/Rotary Club of Tulsa, Tulsa City-County Library and Tulsa Historical Society.)

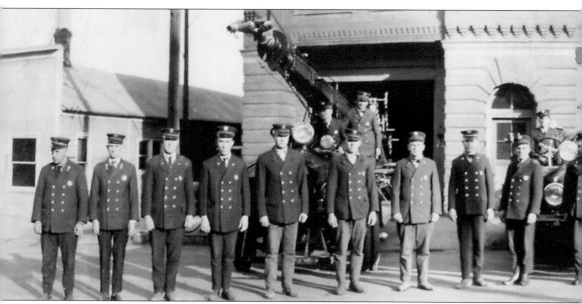

This 1915 group photograph shows the uniformed members of the Tulsa Fire Department. During the course of the riot, members of the mob that invaded the Greenwood District prevented firefighters from dousing the flames that ultimately ravaged the community. This blatant act of

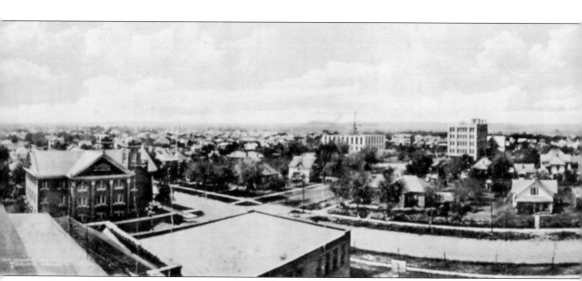

Pictured here is a panoramic view of the Tulsa skyline in 1911. The city's remarkable growth in the ensuing decades was largely attributable to its ties to the oil industry. (Courtesy of the Beryl

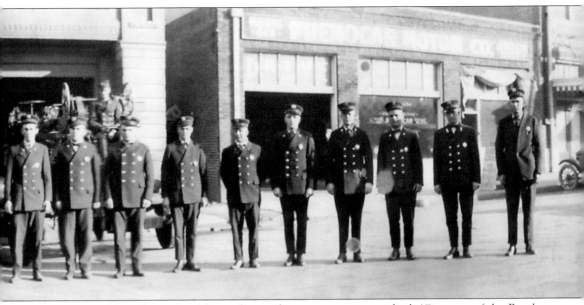

interference, like other unlawful acts during the riot, went unpunished. (Courtesy of the Beryl Ford Collection/Rotary Club of Tulsa, Tulsa City-County Library and Tulsa Historical Society.)

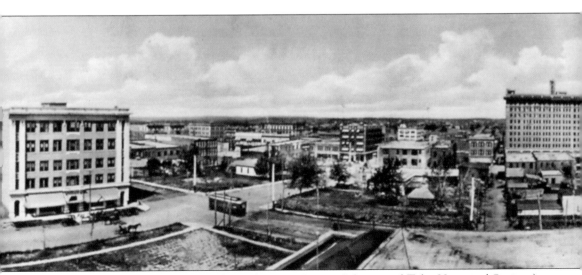

Ford Collection/Rotary Club of Tulsa, Tulsa City-County Library and Tulsa Historical Society.)

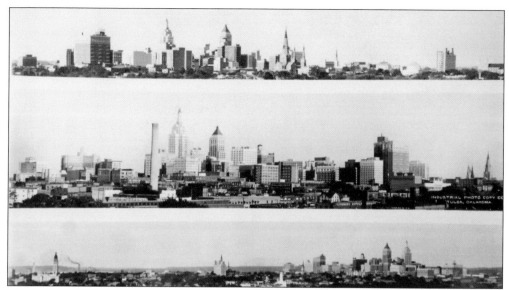

These three 1932 skyline views of Tulsa illustrate the remarkable rise of the city from a once-sleepy Indian Territory outpost to a mid-sized American metropolitan area and the "Oil Capital of the World." (Courtesy of the Beryl Ford Collection/Rotary Club of Tulsa, Tulsa City-County Library and Tulsa Historical Society.)

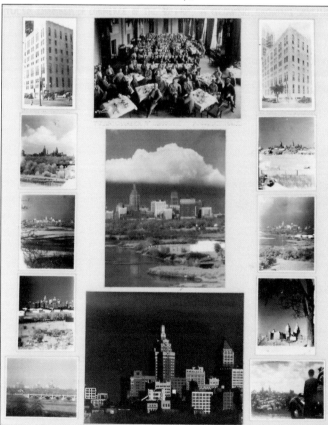

These Tulsa Chamber of Commerce images from the 1930s and 1940s further illustrate Tulsa's trajectory into the American spotlight. The group, now the Tulsa Regional Chamber, continues to be a driving force behind the Tulsa area's prominence as a business-friendly venue. (Courtesy of the Beryl Ford Collection/ Rotary Club of Tulsa, Tulsa City-County Library and Tulsa Historical Society.)

Edward I. Hanlon, James Henaghan, and an unnamed pilot are seated in a pusher type hydroplane owned by the Harlan Oil Company. One of the persistent strains of oral history that endures from the 1921 Tulsa Race Riot recalls planes dropping incendiary devices on the Greenwood District. Authorities at the time admitted that planes flew over the community, but characterized the sorties as reconnoitering missions. (Courtesy of the Beryl Ford Collection/Rotary Club of Tulsa, Tulsa City-County Library and Tulsa Historical Society.)

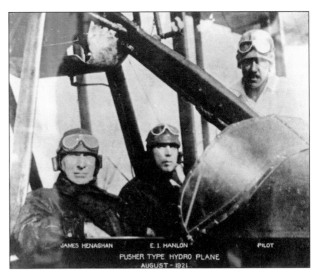

This c. 1940 photograph shows Greenwood Avenue south of Easton Street, looking north along the Sand Springs Railway interurban tracks. The Prince-Mackey (Mabel B. Little) House is visible on the left with a tile roof. The Prince-Mackey House stood on the southwest corner of Greenwood Avenue and Easton Street. It is now located slightly to the south and back from the street, and is part of the Greenwood Cultural Center. The slender building straight ahead is the Del Rio Hotel. (Courtesy of the Beryl Ford Collection/Rotary Club of Tulsa, Tulsa City-County Library and Tulsa Historical Society.)

71

This c. 1940 photograph shows Greenwood Avenue south of Easton Street, looking south along the Sand Springs Railway tracks. Charles Page, a philanthropist and the founder of the city of Sand Springs, created the Sand Springs Railway in 1911. Operating on 8.6 miles of track, the Sand Springs Railway provided service between Tulsa and Sand Springs. The Tulsa passenger terminal was located at the corner of Archer Street and Boston Avenue. In 1955, the Sand Springs Railway discontinued passenger service and changed over to diesel locomotives as a freight line. (Courtesy of the Beryl Ford Collection/Rotary Club of Tulsa, Tulsa City-County Library and Tulsa Historical Society.)

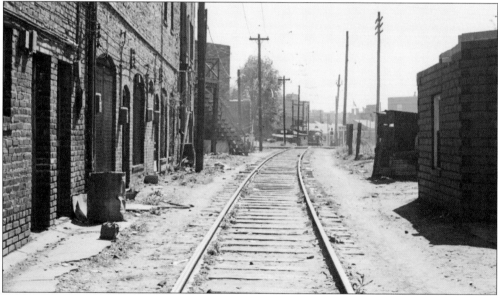

This c. 1940 photograph shows the Sand Springs Railway tracks near Brady Street and Greenwood Avenue, looking southwest. Hotel Tulsa is in the far background. Today, a minor league baseball ballpark, ONEOK Field, sits on the land just to the right of these tracks and is home to the Tulsa Drillers. Professional baseball began in Tulsa in 1905. The Drillers are the oldest professional sports franchise in the city. (Courtesy of the Beryl Ford Collection/Rotary Club of Tulsa, Tulsa City-County Library and Tulsa Historical Society.)

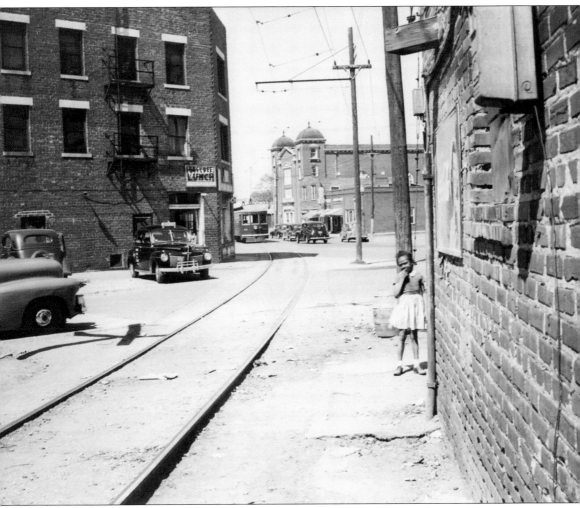

This c. 1940 photograph shows the Sand Springs Railway tracks, looking north toward Brady Street and Greenwood Avenue, Busy Bee Lunch (in the Center Hotel building), and Vernon African Methodist Episcopal (AME) Church to the north. Founded in 1905, Vernon AME was in the process of building a new facility at the time of the 1921 Tulsa Race Riot. Burned to the ground during the melee, the congregation tapped into its savings and secured additional donations in order to rebuild. By the end of 1922, workers completed Vernon AME's basement on the burned site. By 1928, construction of the new Vernon AME had been completed; that structure remains a vital part of the Greenwood District today. Likewise, the building in the foreground remains. The area in between is now occupied by an overpass for Interstate 244. (Courtesy of the Beryl Ford Collection/Rotary Club of Tulsa, Tulsa City-County Library and Tulsa Historical Society.)

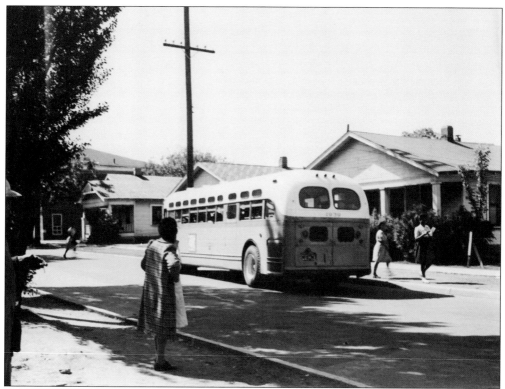

A bus services Easton Street, west of Greenwood Avenue, around the 1950s. African American businessman Simon Berry pioneered transportation service in the Greenwood District with jitney, bus, and charter plan services. (Courtesy of the Beryl Ford Collection/Rotary Club of Tulsa, Tulsa City-County Library and Tulsa Historical Society.)

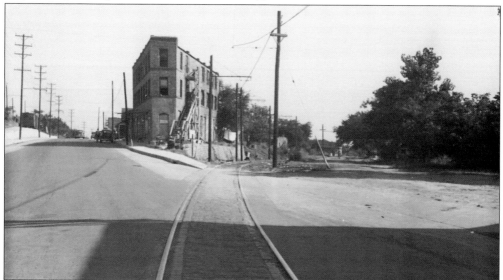

Pictured here is Greenwood Avenue in the 1950s at its intersection with Greenwood Place, which parallels the Sand Springs Railway interurban tracks branching to the right. (Courtesy of the Beryl Ford Collection/Rotary Club of Tulsa, Tulsa City-County Library and Tulsa Historical Society.)

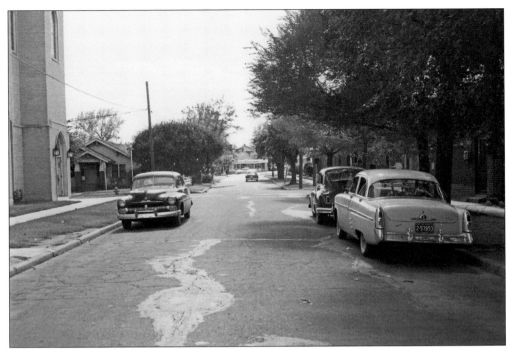

This July 26, 1955, photograph looks east on Easton Street in the Greenwood District. (Courtesy of the Beryl Ford Collection/Rotary Club of Tulsa, Tulsa City-County Library and Tulsa Historical Society.)

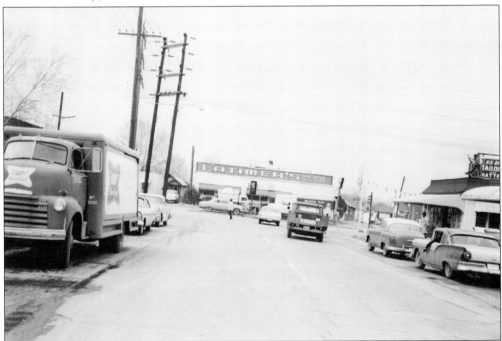

Greenwood Avenue and the Pine Street area on Tulsa's north side are pictured in this c. 1950s photograph. (Courtesy of the Beryl Ford Collection/Rotary Club of Tulsa, Tulsa City-County Library and Tulsa Historical Society.)

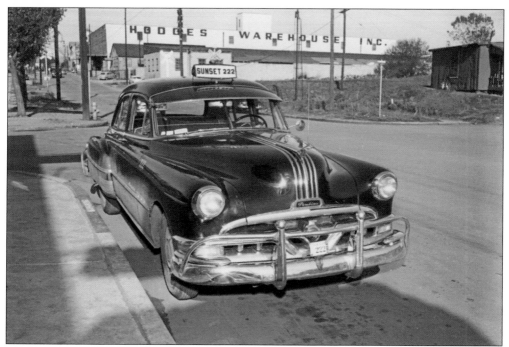

This April 16, 1953, photograph features a Sunset Cab in the Greenwood District. (Courtesy of the Beryl Ford Collection/Rotary Club of Tulsa, Tulsa City-County Library and Tulsa Historical Society.)

This April 9, 1953, photograph shows the 600 block of East Pine Street in the Greenwood District. (Courtesy of the Beryl Ford Collection/Rotary Club of Tulsa, Tulsa City-County Library and Tulsa Historical Society.)

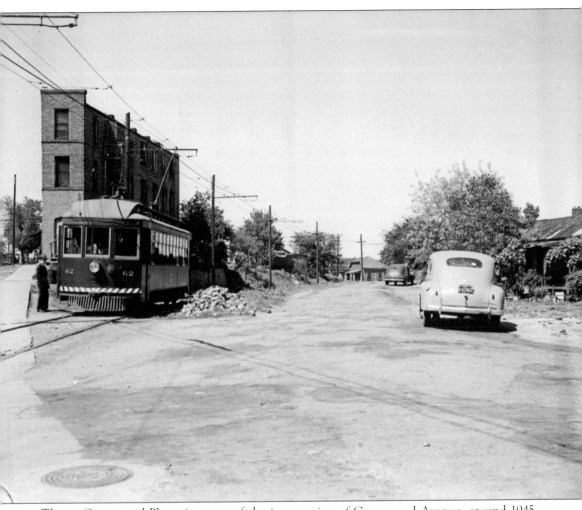

This is Greenwood Place, just east of the intersection of Greenwood Avenue, around 1945. The Sand Springs Railway Car 62 is pictured in front of the Del Rio Hotel. Car 62, which was built in 1917, was acquired by the Sand Springs Railway in 1932 from the Cincinnati, Lawrenceburg & Aurora, and scrapped in 1947. At that time, the city acquired newer cars from the Oklahoma Union Railway, an interurban line connecting Nowata, Coffeyville, and Independence. (Courtesy of the Beryl Ford Collection/Rotary Club of Tulsa, Tulsa City-County Library and Tulsa Historical Society.)

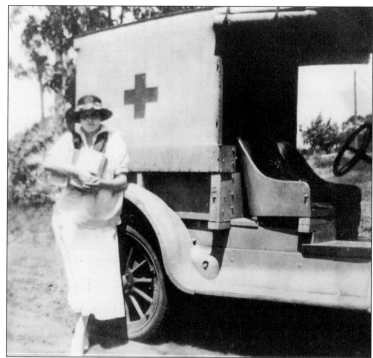

This 1918 photograph of the American Red Cross in Tulsa foreshadows the dark days ahead. The Red Cross, led by St. Louis-based Maurice Willows, provided extensive post-riot relief in Tulsa, for which it was widely praised. (Courtesy of the Beryl Ford Collection/Rotary Club of Tulsa, Tulsa City-County Library and Tulsa Historical Society.)

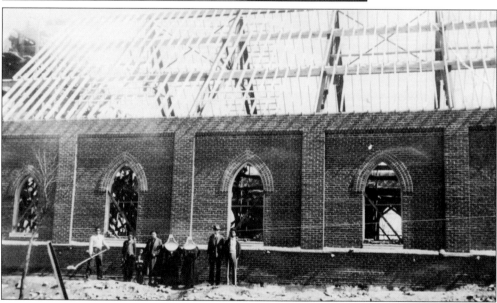

Post-riot rebuilding in the Greenwood District began almost immediately. In 1925, the Greenwood District hosted the conference of what might be called the Black Chamber of Commerce. The group, known as the National Negro Business League, was founded in Boston, Massachusetts, in 1900 by Booker T. Washington with the support of Andrew Carnegie. The league promoted black commerce and economic uplift as a necessary prerequisite to equality for African Americans. It launched 320 chapters nationwide, with diverse members representing small businesses, professionals, farmers, craftsmen, and more. In 1966, the league reincorporated in Washington, DC, as the National Business League. (Courtesy of the Greenwood Cultural Center.)

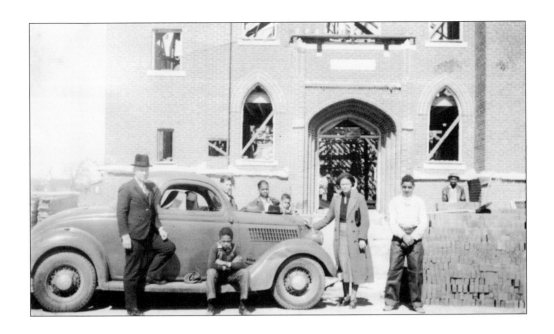

Tulsa's historic Mount Zion Baptist Church was destroyed in the 1921 Tulsa Race Riot by a mob that believed the church was a storehouse for munitions secreted by the African Americans in the Greenwood District. Only the dirt-floor basement of the church remained after its burning. These photographs illustrate the rebuilding of this iconic religious structure. (Both, courtesy of the Greenwood Cultural Center.)

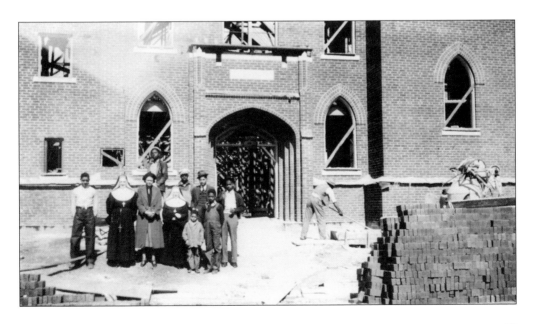

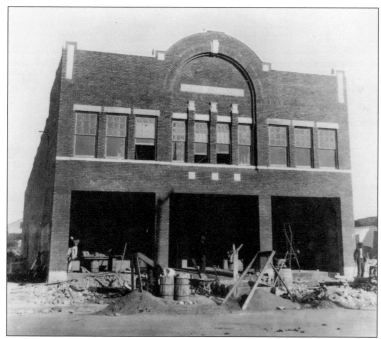

The Williams Dreamland Theater, shown here under reconstruction in the mid-to-late 1920s, was one of several businesses owned and operated by John and Loula Williams. The Dreamland, located on Greenwood Avenue in the heart of the Greenwood District, was destroyed in the riot, but rebuilt in grand style. (Courtesy of the Greenwood Cultural Center.)

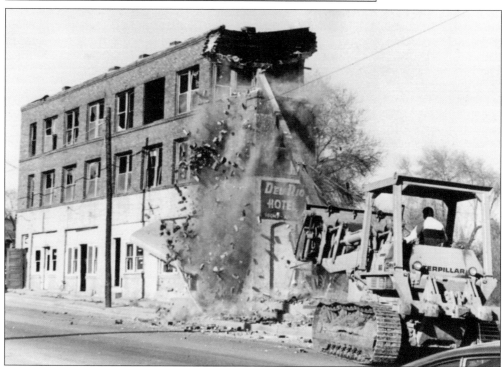

Urban renewal, a controversial land redevelopment program, wreaked havoc on the Greenwood District, particularly in the 1960s and 1970s. Wrecking balls pummeled buildings, demolishing not just structures, but the history embedded in them. Some African American leaders pejoratively referred to the urban renewal efforts as "urban removal." Here, a bulldozer fells a Greenwood District structure around 1970. (Courtesy of the Greenwood Cultural Center.)

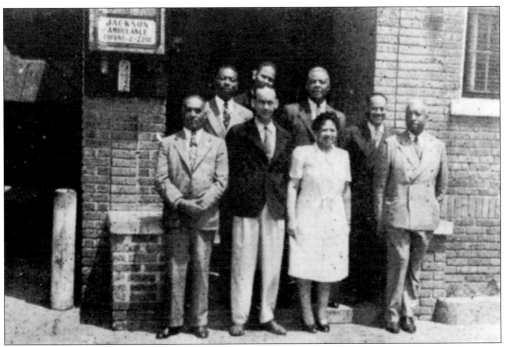

Jackson's Ambulance, located on Archer Street, was a prominent Greenwood District business during the 1940s. (Courtesy of the Greenwood Cultural Center.)

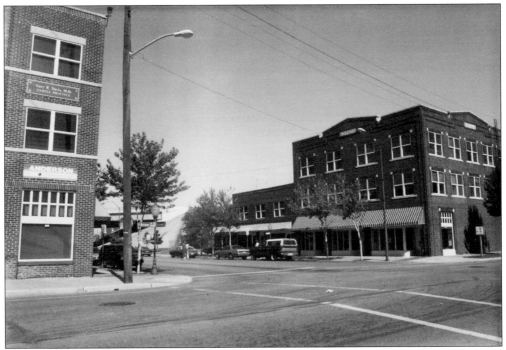

This c. 1985 photograph looks northeast at the intersection of Archer Street and Greenwood Avenue. (Courtesy of the Greenwood Cultural Center.)

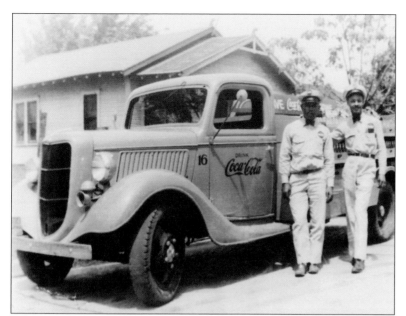

Shown on the right in this c. 1940 image is George Monroe, a 1921 Tulsa Race Riot survivor and the first African American distribution and deliveryman for Coca-Cola in Tulsa. (Courtesy of the Greenwood Cultural Center.)

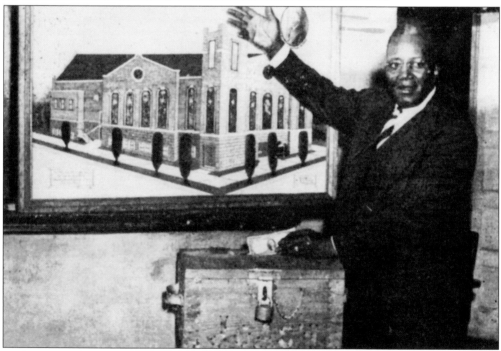

In the 1940s, this unidentified man is making a deposit in the Biblically-inspired Joash Chest, one of several creative fundraising initiatives sponsored by Mount Zion Baptist Church. Other initiatives included the White Elephants Drive and the Envelope System. Rioters destroyed the sparkling new Mount Zion structure in the 1921 Tulsa Race Riot after a rumor circulated that the church was being used to store arms for the African American community. Rioters succeeded in destroying the façade, but not the church—the people who gave life and spirit to the building. Eventually, Mount Zion managed to pay off the mortgage on the destroyed structure and build a new one. (Courtesy of the Greenwood Cultural Center.)

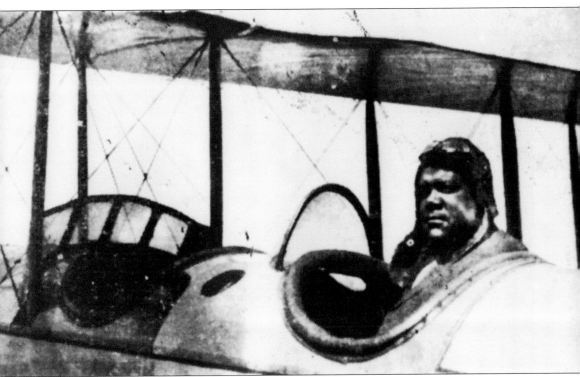

In the 1920s, Simon Berry was a Tulsa aviator and transportation magnate. In addition to his charter plane operations, Berry started a jitney service in the Greenwood District, founded a successful bus line, and served as the proprietor of the Royal Hotel. (Courtesy of the Greenwood Cultural Center.)

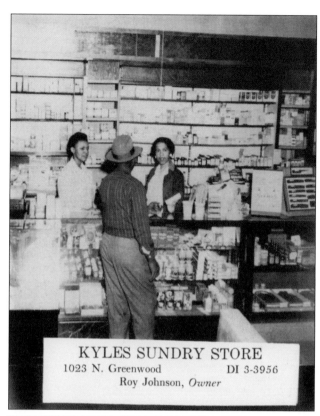

KYLES SUNDRY STORE
1023 N. Greenwood DI 3-3956
Roy Johnson, *Owner*

Roy Johnson owned Kyle's Sundry Store in the Greenwood District in the 1940s. Entrepreneurship flourished in the "Negro Wall Street." (Courtesy of the Greenwood Cultural Center.)

Pictured here is an unidentified store in the Greenwood District in the 1940s, an example of the many small shops and professional service providers leading the entrepreneurial charge. (Courtesy of the Greenwood Cultural Center.)

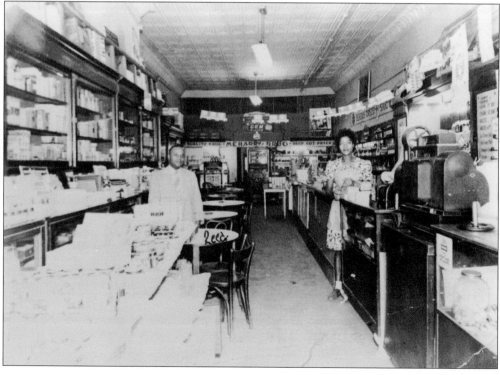

Here is another unidentified store in the Greenwood District in the 1940s. Segregation prevented African Americans from unfettered commerce with white businesses and professionals. Black businesses flourished in the closed economy. (Courtesy of the Greenwood Cultural Center.)

RAMSEY DRUG STORE
1202 N. Greenwood Avenue LU 4-9495

Ramsey Drug Store, shown here in the 1960s, became a Greenwood District staple. Due to segregation, the Greenwood District, in many ways, functioned as a segregated city with Tulsa. (Courtesy of the Greenwood Cultural Center.)

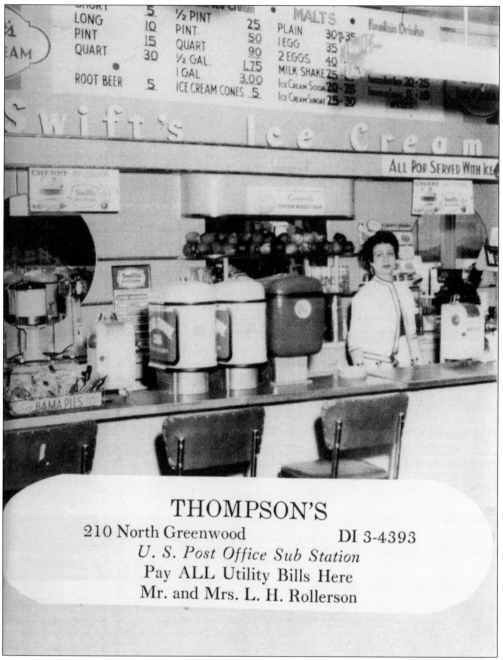

THOMPSON'S

210 North Greenwood DI 3-4393
U. S. Post Office Sub Station
Pay ALL Utility Bills Here
Mr. and Mrs. L. H. Rollerson

Thompson's was another successful African American business in the Greenwood District in the 1960s. (Courtesy of the Greenwood Cultural Center.)

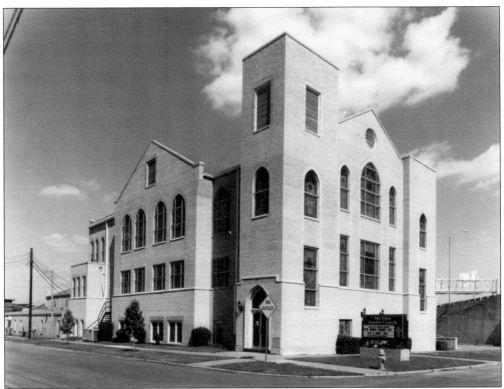

Mount Zion Baptist Church suffered devastating damage during the 1921 Tulsa Race Riot, but congregants rebuilt it. Pictured here in the 1990s, the church is now an integral part of the modern Greenwood District. (Courtesy of the Greenwood Cultural Center.)

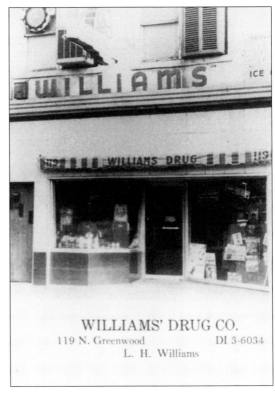

WILLIAMS' DRUG CO.
119 N. Greenwood DI 3-6034
L. H. Williams

For many years, the Greenwood District operated in some respects as an insular economy just beyond the boundaries of white Tulsa. Businesses like William's Drug Co., pictured here in the 1960s, took advantage. (Courtesy of the Greenwood Cultural Center.)

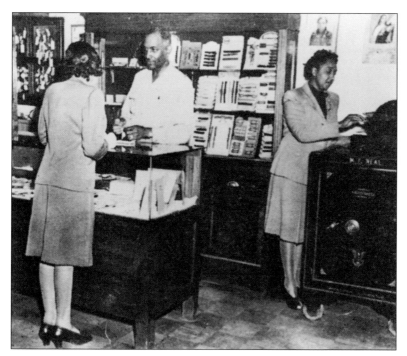

Thursday, "maid's day off," proved to be a popular shopping day in the Greenwood District. African American women who worked for white families strolled and shopped in the area during this brief respite from the workaday world. (Courtesy of the Greenwood Cultural Center.)

Even as opportunities in the outside world remained limited, entrepreneurship flourished in the Greenwood District. Integration, urban renewal, the changing economy, and a lack of systematic business mentoring led to the decline of the Greenwood District in the ensuing decades. (Courtesy of the Greenwood Cultural Center.)

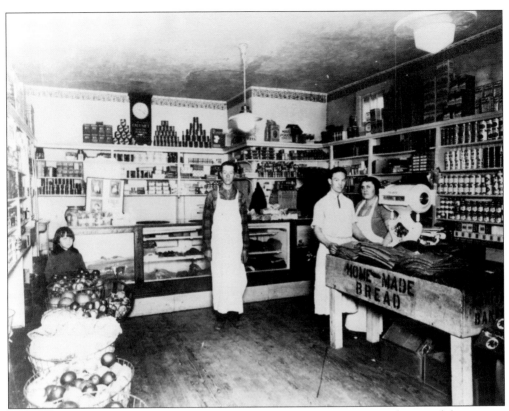

Shown here is the interior of a grocery store in the Greenwood District. People around the country took note of the business opportunities available in this Tulsa neighborhood. (Courtesy of the Greenwood Cultural Center.)

The entrepreneurial spirit in the Greenwood District created a profound sense of place. In the mid-20th century, local businesses such as the Rex Theater, pictured here, populated the neighborhood. (Courtesy of the Greenwood Cultural Center.)

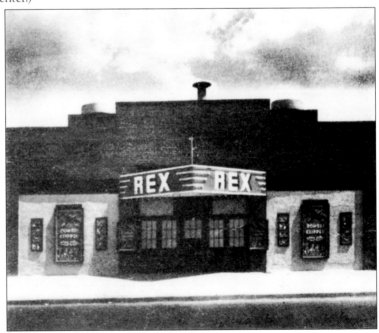

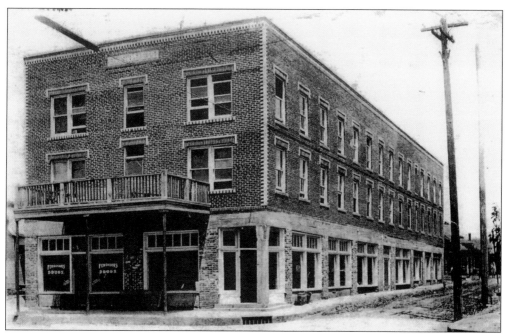

Ferguson's Drugs was one of the many local businesses that could be found in the Greenwood District. (Courtesy of the Greenwood Cultural Center.)

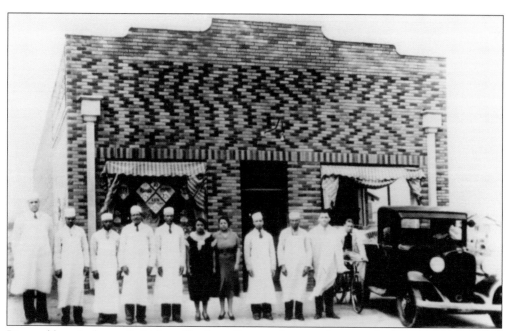

Pictured here is the staff of Mann Brothers Grocery Store on Lansing Street in the Greenwood District in the 1940s. Small shops and professional service providers abounded. (Courtesy of the Greenwood Cultural Center.)

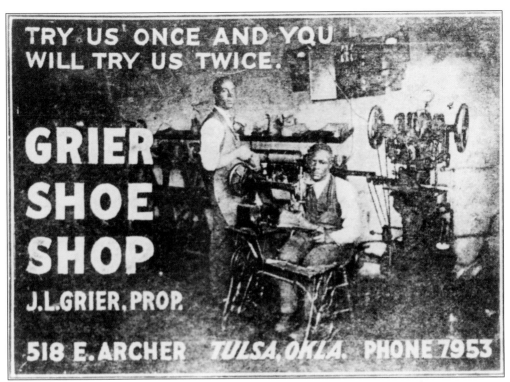

This c. 1920 photograph shows Grier Shoe Shop on Greenwood Avenue. The store's motto appears prominently: "Try us once and you will try us twice." (Courtesy of the Greenwood Cultural Center.)

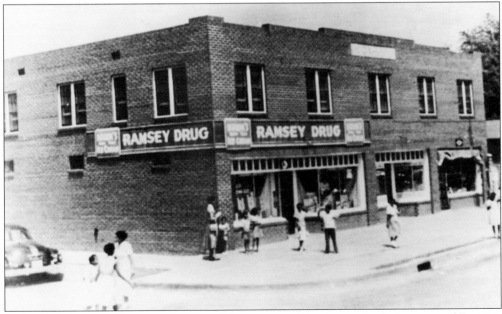

In the 1950s, Ramsey Drugs was but one of the many small businesses in the Greenwood District. Enterprises came together in this Tulsa neighborhood to create a national sensation. (Courtesy of the Greenwood Cultural Center.)

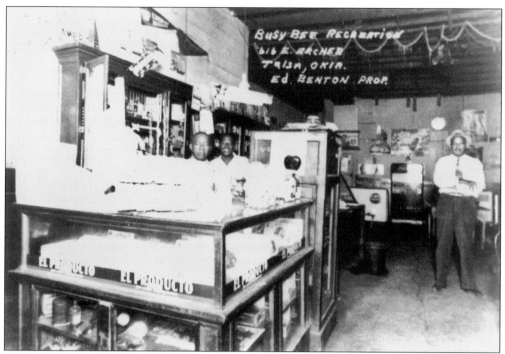

This undated photograph shows Busy Bee Recreation, at 616 East Archer Street in the Greenwood District. (Courtesy of the Greenwood Cultural Center.)

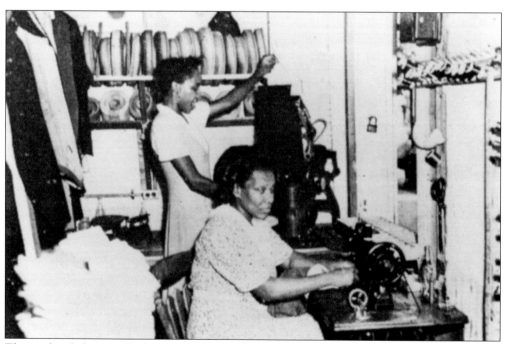

This undated photograph shows a seamstress shop in the Greenwood District. Entrepreneurship flourished, with small shops and professional service providers leading the charge. (Courtesy of the Greenwood Cultural Center.)

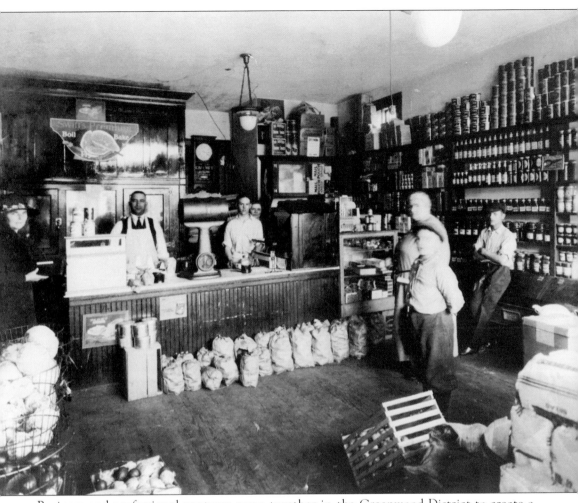

Business and professional ventures came together in the Greenwood District to create a critical mass that served Tulsa's African American community. (Courtesy of the Greenwood Cultural Center.)

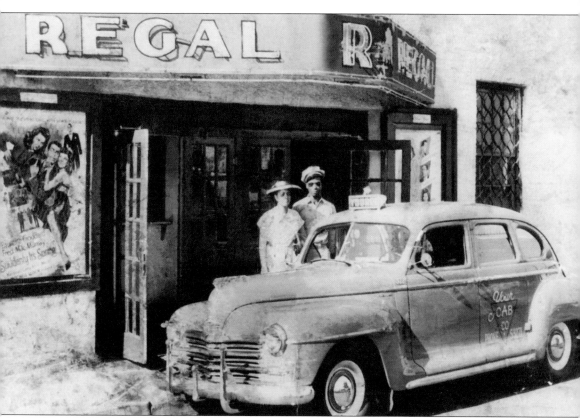

The Regal Theater and Your Cab Company both operated successful enterprises in the Greenwood District around the 1950s. (Courtesy of the Greenwood Cultural Center.)

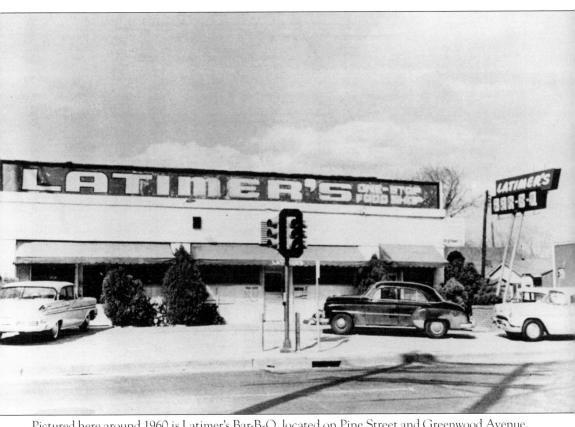

Pictured here around 1960 is Latimer's Bar-B-Q, located on Pine Street and Greenwood Avenue. The Latimer name became synonymous with top-notch barbeque and, more particularly, barbeque sauce. (Courtesy of the Greenwood Cultural Center.)

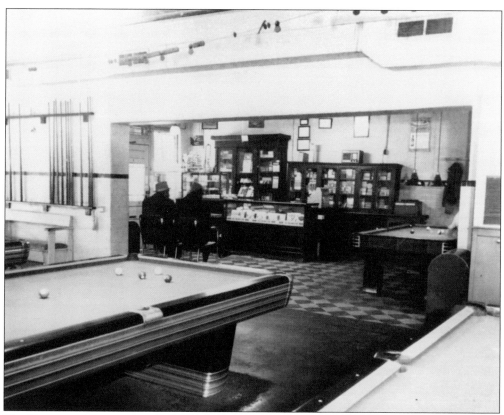

The Greenwood District was also home to this unidentified pool hall. (Courtesy of the Greenwood Cultural Center.)

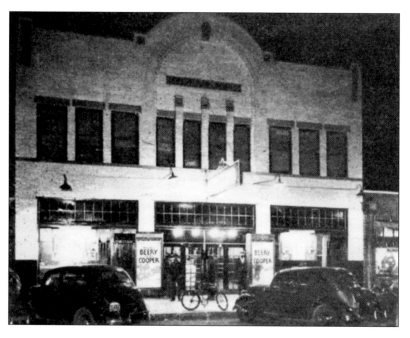

The Williams Dreamland Theater, pictured here during the 1940s and owned by John and Loula Williams, was rebuilt after its destruction in the 1921 Tulsa Race Riot. (Courtesy of the Greenwood Cultural Center.)

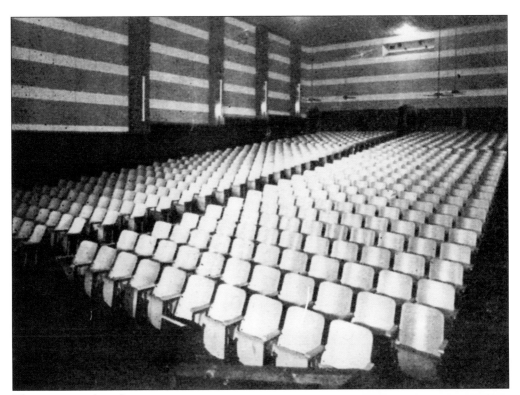

The seating within the Dreamland Theater is shown in this 1940s photograph. (Courtesy of the Greenwood Cultural Center.)

Bowser's Prescription Shop, located on Greenwood Avenue, is shown in this 1950s photograph. Entrepreneurship flourished in the Greenwood District, with professional service providers like Bowser's playing a crucial role. (Courtesy of the Greenwood Cultural Center.)

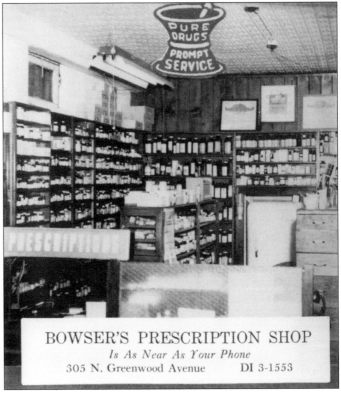

BOWSER'S PRESCRIPTION SHOP
Is As Near As Your Phone
305 N. Greenwood Avenue DI 3-1553

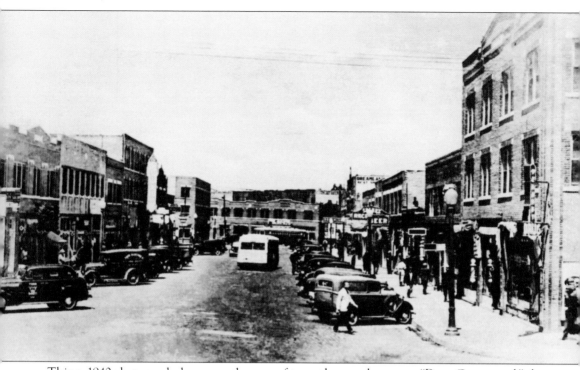

This c. 1940 photograph showcases the area of town that was known as "Deep Greenwood," the intersection of Archer Street and Greenwood Avenue and the 100 block of Greenwood Avenue. (Courtesy of the Greenwood Cultural Center.)

Four

RENAISSANCE

Someday, after mastering the winds, the waves, the tides and gravity, we shall harness for God the energies of love, and then, for a second time in the history of the world, man will have discovered fire.
—Pierre Teilhard de Chardin

The Greenwood District has not, and likely will not, reclaim the mantle of black entrepreneurial mecca. Yet, despite its inability to capture that initial magic, it is in the midst of a renaissance. The 21st-century Greenwood District is a critical component of a larger arts, entertainment, education, and cultural complex that includes the adjacent Brady District.

Several key developments highlight the rebirth of the Greenwood District. Prominent among them are the formation of the Greenwood Cultural Center and the Oklahoma Jazz Hall of Fame in the 1980s. These institutions offered Tulsans both conceptual and physical space within which to celebrate the legacy of this historic community.

National attention also helped propel interest in the Greenwood District. After decades of near silence, the ghosts of Greenwood District past emerged as American newspapers began to examine the riot. From *The New York Times* to *The Wall Street Journal*, from *The Los Angeles Times* to *The San Francisco Examiner*, major newspapers covered the riot, the worst such event in American history. Numerous riot-based documentaries and other treatments soon followed, including *The Night Tulsa Burned* and *Burn: The Evolution of an American City*.

Perhaps the single greatest contributor to this expanded exposure was the 11-member Oklahoma Commission to Study the Tulsa Race Riot of 1921, whose deliberations garnered world-wide media attention. The commission's final report in February 2001, named *Tulsa Race Riot: A Report by the Oklahoma Commission to Study the Tulsa Race Riot of 1921*, chronicled the facts surrounding the riot and made five reparations recommendations: cash payments to survivors, cash payments to heirs of survivors who demonstrated property loss, establishment of an educational scholarship fund for survivors' descendants, business development incentives for the Greenwood District, and a memorial/museum.

The Oklahoma legislature created several new initiatives in response to the commission's report. John Hope Franklin Reconciliation Park, funded by the State of Oklahoma, City of Tulsa, and private contributions, is one success story tied directly to the commission's work and the follow-through of the Oklahoma legislature.

The riot, for all its importance and implications, is only part of the remarkable story of the Greenwood District. An understanding of who the Greenwood District founders were and what they built before and rebuilt after the riot places that cataclysmic event in context.

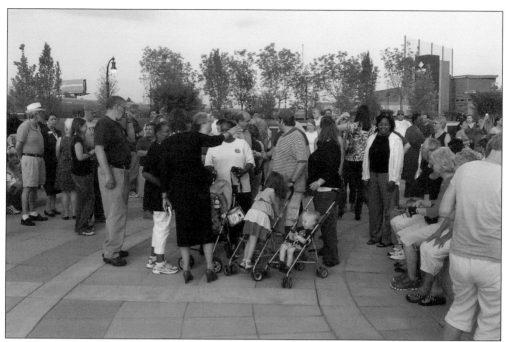

On May 31, 2011, the 90th anniversary of the 1921 Tulsa Race Riot, a group gathered at John Hope Franklin Reconciliation Park for a candlelight vigil and walk through the Greenwood District. (Courtesy of the John Hope Franklin Center for Reconciliation.)

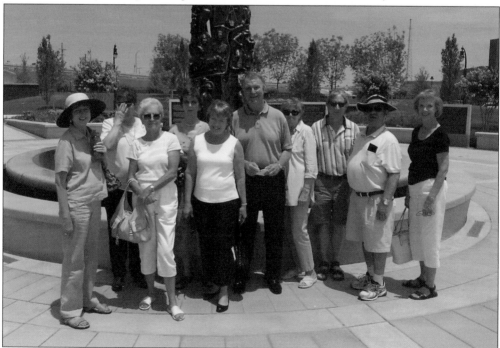

A group of Tulsa Historical Society volunteers gathered at John Hope Franklin Reconciliation Park in June 2011. The centerpiece of the park, *Reconciliation Towers*, appears behind the group. (Courtesy of the John Hope Franklin Center for Reconciliation.)

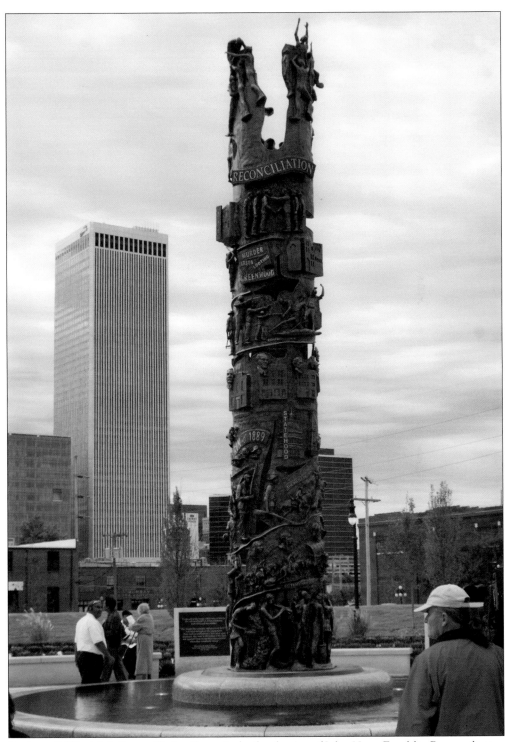

Sculptor Ed Dwight's *Reconciliation Tower* is the focal point of John Hope Franklin Reconciliation Park in Tulsa. This photograph looks southwest toward downtown Tulsa. (Courtesy of the John Hope Franklin Center for Reconciliation.)

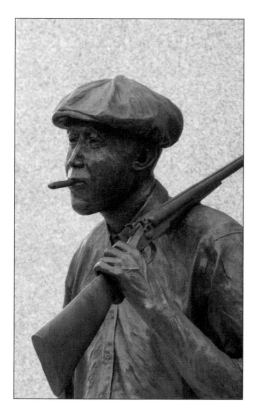

Pictured here is sculptor Ed Dwight's piece *Hostility*, part of three statues depicting hostility, humiliation, and hope in connection with the 1921 Tulsa Race Riot. Dwight, the first African American astronaut and a prominent artist, sculpted the 16-foot granite structure with three larger-than-life bronze sculptures representing actual photographs from the 1921 Tulsa Race Riot. The sculptures stand in Hope Plaza in John Hope Franklin Reconciliation Park. (Both, courtesy of the John Hope Franklin Center for Reconciliation.)

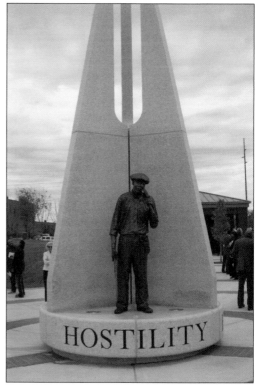

Humiliation is part of Ed Dwight's three statues depicting hostility, humiliation, and hope. It depicts a black man with his hands raised in surrender. (Courtesy of the John Hope Franklin Center for Reconciliation.)

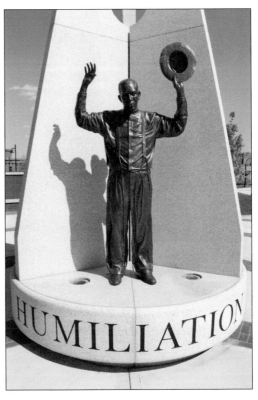

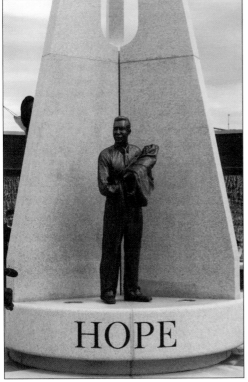

Hope shows the white director of the American Red Cross holding an African American baby. The formal opening and dedication of John Hope Franklin Reconciliation Park took place on October 27, 2010. The mission of the John Hope Franklin Center for Reconciliation is to transform society's divisions into social harmony through the serious study and work of reconciliation. Consistent with its mission, the center sponsors various forums that promote dialogue and discussion. (Courtesy of the John Hope Franklin Center for Reconciliation.)

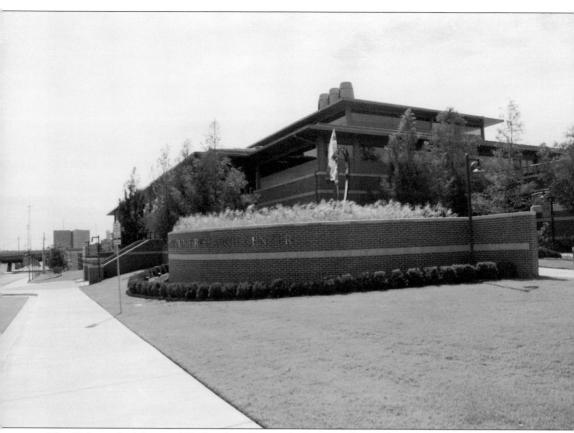

The Helmerich Advanced Technology Research Center is located on the campus of Oklahoma State University–Tulsa, which sits in the heart of the Greenwood District. (Courtesy of I. Marc Carlson, librarian of Special Collections and University Archives, the University of Tulsa.)

This 2012 photograph shows a walkway on the campus of Oklahoma State University–Tulsa, a major presence in the modern Greenwood District. Oklahoma State University–Tulsa, opened on January 1, 1999, is the newest institution in the Stillwater-based Oklahoma State University system. The campus had previously been home to an educational consortium known as the University Center at Tulsa (UCAT). (Courtesy of I. Marc Carlson, librarian of Special Collections and University Archives, the University of Tulsa.)

Shown here is a monument to legendary Booker T. Washington High School principal Ellis Walker Woods, who led the school for more than three decades and died in 1948. The original brick Booker T. Washington High School, founded in 1913, sat on the site occupied today by Oklahoma State University–Tulsa. (Courtesy of I. Marc Carlson, librarian of Special Collections and University Archives, the University of Tulsa.)

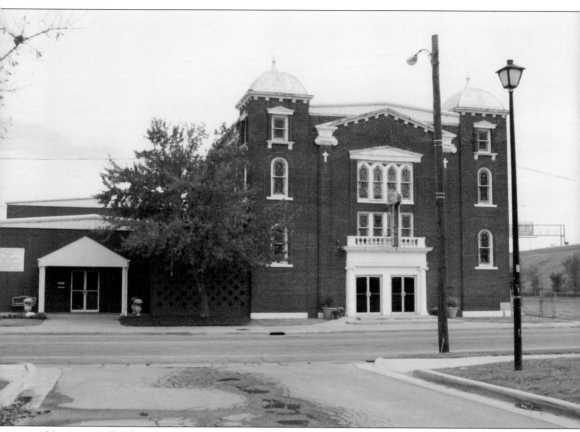

Vernon AME Church on Greenwood Avenue is one of two major churches (the other being Mount Zion Baptist Church) in the Greenwood District directly affected by the 1921 Tulsa Race Riot. (Courtesy of I. Marc Carlson, librarian of Special Collections and University Archives, the University of Tulsa.)

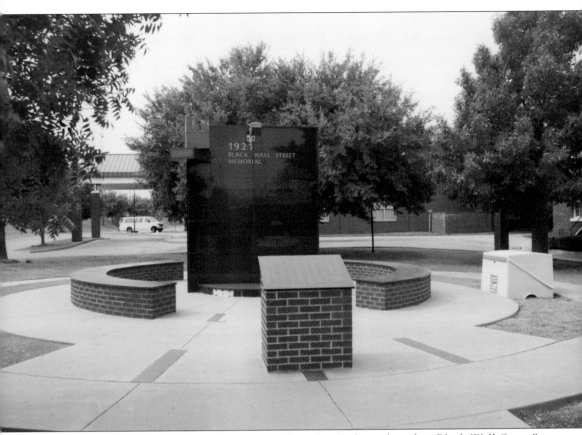

At Greenwood Cultural Center is a memorial marker dedicated to the "Black Wall Street" businesses that once dotted the community's landscape. Ground-breaking for the Greenwood Cultural Center (GCC) took place in August 1985. Built at a cost of almost $3 million, GCC was built in three phases: the restoration and opening of the Mabel B. Little Heritage House in September of 1986; the construction of the Goodwin-Chappelle Gallery, which opened on April 4, 1989; and the building of facilities to house the Oklahoma Jazz Hall of Fame and the Opal Dargan Renaissance Hall, completed in 1996. GCC serves as a tribute to Greenwood District history and as a beacon of hope for the future. The venue features an African American art gallery and a large banquet hall. GCC housed the Oklahoma Jazz Hall of Fame until 2007, and its educational and cultural events help preserve African American heritage and promote positive images of the community. (Courtesy of I. Marc Carlson, librarian of Special Collections and University Archives, the University of Tulsa.)

The Mabel B. Little House is part of the Greenwood Cultural Center. The house honors Mabel B. Little, a Greenwood District pioneer and activist who arrived on the scene in 1913. (Courtesy of I. Marc Carlson, librarian of Special Collections and University Archives, the University of Tulsa.)

The overpass for Interstate 244 bisects what was once the heart of the Greenwood District. Not just in Tulsa, but nationwide, expressways spawned by the urban renewal movement had unintended consequences: displaced and severed communities, environmental degradation, and land use compromises, just to name a few. Urban art is visible just beneath the overpass. (Courtesy of I. Marc Carlson, librarian of Special Collections and University Archives, the University of Tulsa.)

This 2012 photograph shows Greenwood Avenue, looking north. Once upon a time, commentators drew favorable comparisons of this thoroughfare to Beale Street in Memphis and State Street in Chicago. (Courtesy of I. Marc Carlson, librarian of Special Collections and University Archives, the University of Tulsa.)

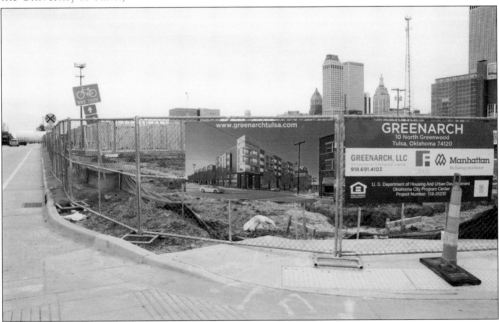

Under construction, GreenArch, a $9.5 million, four-story, 86,268-square-foot property, will offer mixed-use, affordable living spaces. The property will feature loft-style studio apartments and more than 9,000 square feet of commercial and retail space with live/work residential units. Onsite parking will be provided on the southwest corner of Greenwood Avenue and Archer Street. GreenArch will complement the Greenwood District and its neighbor to the northwest, ONEOK Field. (Courtesy of I. Marc Carlson, librarian of Special Collections and University Archives, the University of Tulsa.)

Pictured here is Williams Building No. 1, a pre-riot structure. The lower portion of the building contains original brickwork. (Courtesy of I. Marc Carlson, librarian of Special Collections and University Archives, the University of Tulsa.)

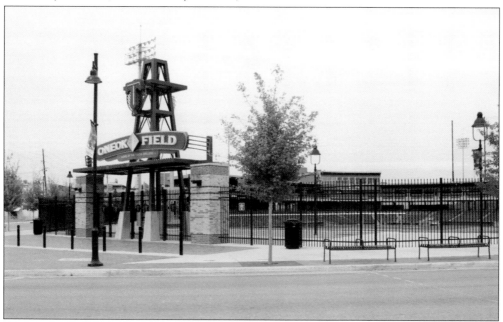

ONEOK Field is the home of the minor league baseball team the Tulsa Drillers. This baseball park has become a prominent part of the Greenwood District and, arguably, an engine of economic revitalization. (Courtesy of I. Marc Carlson, librarian of Special Collections and University Archives, the University of Tulsa.)

These are aerial views of the current Booker T. Washington High School, located at 1514 East Zion Street in Tulsa. The high school is now a magnet school that offers the International Baccalaureate Diploma Program (IB). The IB, primarily for students aged 16–19, provides an internationally accepted and recognized qualification for entry into higher education. (Both, courtesy of the Greenwood Cultural Center.)

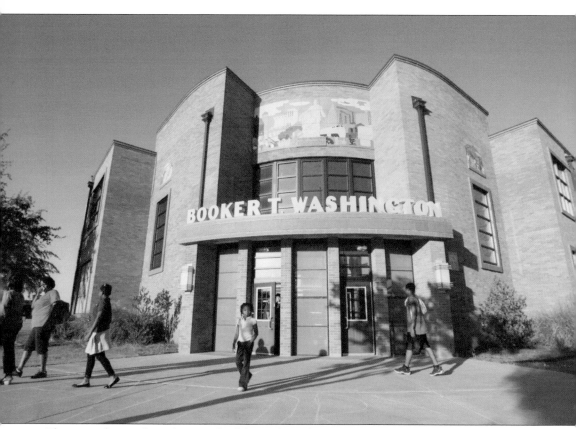

This is another modern photograph of the acclaimed Booker T. Washington High School. Booker T. Washington offers top-flight secondary education for those students fortunate enough to gain admittance. (Courtesy of the Greenwood Cultural Center.)

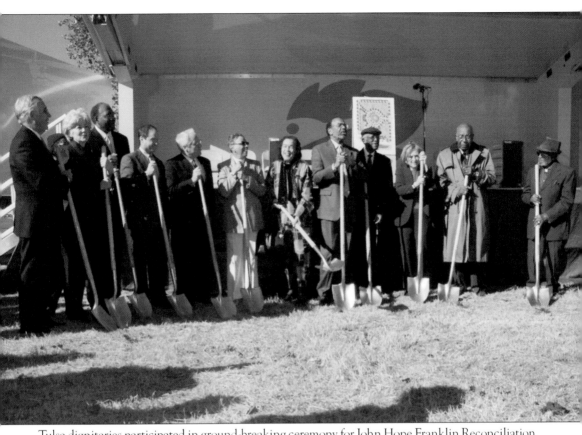

Tulsa dignitaries participated in ground-breaking ceremony for John Hope Franklin Reconciliation Park on November 17, 2008. (Courtesy of the John Hope Franklin Center for Reconciliation.)

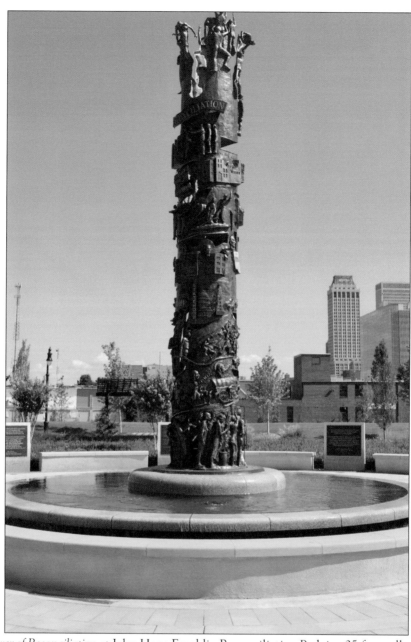

The *Tower of Reconciliation* at John Hope Franklin Reconciliation Park is a 25-foot-tall memorial that sits at the center of the park. It depicts the history of the African American struggle from Africa to America: the migration of slaves with Native Americans on the Trail of Tears; the slave labor experience in the territories; the First Kansas Colored Volunteer Infantry, victors in the Battle of Honey Springs; Oklahoma statehood in 1907; the immigration of free blacks into Oklahoma and the changes wrought by statehood in 1907; the all-black towns in Oklahoma; and the rich history of the Greenwood District. The *Tower of Reconciliation* honors Buck C. Franklin, prominent attorney and father of Dr. John Hope Franklin, the park's namesake, and other early African American leaders in Tulsa. (Courtesy of I. Marc Carlson, librarian of Special Collections and University Archives, the University of Tulsa.)

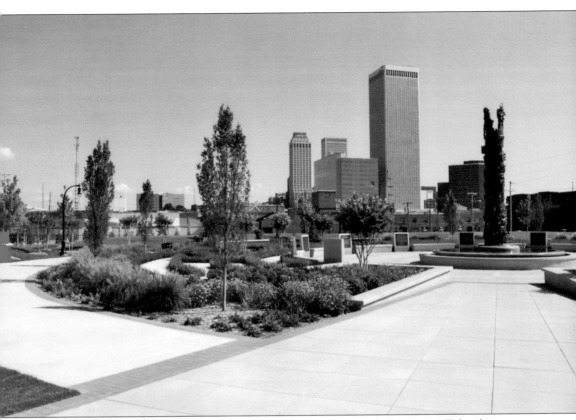

Pictured in 2012 is John Hope Franklin Reconciliation Park, with downtown Tulsa skyscrapers to the south. The park is named in honor of celebrated American historian Dr. John Hope Franklin, whose 1947 classic *From Slavery to Freedom: A History of African Americans*, remains the preeminent text on African American history. (Courtesy of I. Marc Carlson, librarian of Special Collections and University Archives, the University of Tulsa.)

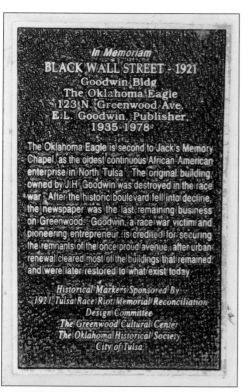

This Black Wall Street memorial plaque honors the Goodwin Building, *The Oklahoma Eagle* (123 North Greenwood Avenue), and E.L. Goodwin, publisher of *The Oklahoma Eagle*. *The Oklahoma Eagle* is a long-standing African American community newspaper in Tulsa that is still associated with the Goodwin family. (Courtesy of the Greenwood Cultural Center.)

Dr. John Hope Franklin greeted Tulsa mayor Kathy Taylor at the John Hope Franklin Reconciliation Park groundbreaking ceremony on November 17, 2008. (Courtesy of the John Hope Franklin Center for Reconciliation.)

On October 27, 2010, a crowd assembled for the formal opening and dedication of John Hope Franklin Reconciliation Park, operated by the John Hope Franklin Center for Reconciliation. The John Hope Franklin Center for Reconciliation focuses on several broad initiatives: Education—increasing public knowledge and understanding, Scholarship—creating new knowledge through scholarly work, Community Outreach—opening conversations to bring communities together, and Archives—laying a foundation for scholarship by gathering materials for research. (Courtesy of the John Hope Franklin Center for Reconciliation.)

Above, the Tulsa community gathered for the October 27, 2010, formal opening and dedication of John Hope Franklin Reconciliation Park. Below, Tulsa dignitaries took part in a ribbon cutting at the formal opening and dedication. (Both, courtesy of the John Hope Franklin Center for Reconciliation.)

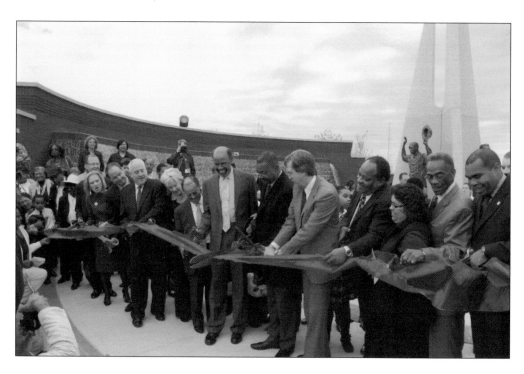

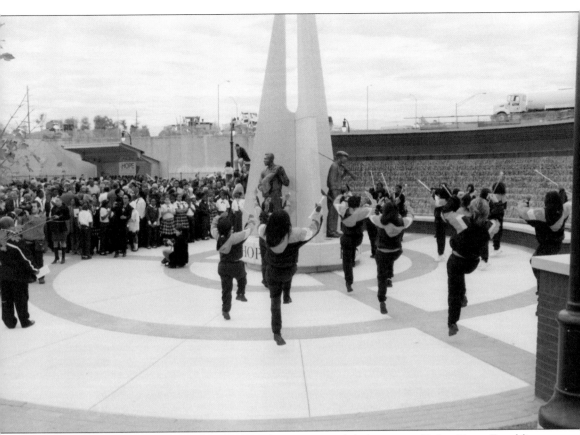

Festivities were in full swing at the formal opening and dedication of John Hope Franklin Reconciliation Park. (Courtesy of the John Hope Franklin Center for Reconciliation.)

Dr. John Hope Franklin visited with former Tulsa mayor M. Susan Savage at the John Hope Franklin Reconciliation Park ground-breaking ceremony on November 17, 2008. Dr. Franklin served as advisor to the Oklahoma Commission to Study the Tulsa Race Riot of 1921, a legislatively impaneled body charged with finding facts and making recommendations in connection with the riot. The commission met from 1997 to 2001 and issued its final report on February 28, 2001. (Courtesy of the John Hope Franklin Center for Reconciliation.)

Julius Pegues, chairman of the board of directors of the John Hope Franklin Center for Reconciliation, introduced Dr. John Hope Franklin at the John Hope Franklin Reconciliation Park ground-breaking ceremony on November 17, 2008. (Courtesy of the John Hope Franklin Center for Reconciliation.)

Mabel B. Little, seen here in 1988, was a Greenwood District matriarch. She died on January 13, 2001, at the age of 104. Little, the granddaughter of emancipated slaves, arrived in Tulsa in 1913 from the all-black Oklahoma town of Boley. Initially, she worked at the Brady Hotel for $20 a month. One year later, she met and married Presley Little. In 1917, Little opened the first beauty shop in her more than 50-year career as a beautician. In 1921, she and her husband built a new shop, home, and rental house. Two weeks and four days after completion, the properties were destroyed in the riot. Little and her husband adopted a total of 12 children. (Courtesy of the *Tulsa World*.)

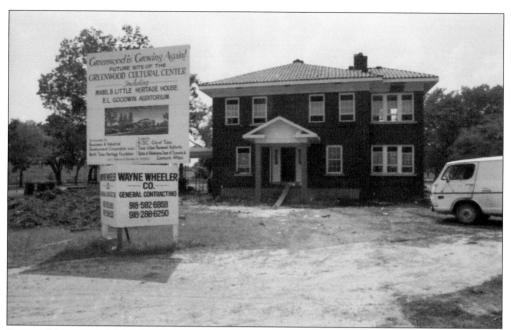

Pictured here in June 1986 is the Mabel B. Little Heritage Museum. The museum is part of the Greenwood Cultural Center, which began construction in late August 1985 at 300 North Greenwood Avenue. (Courtesy of the *Tulsa World.*)

Mabel B. Little, seen here in 1990, chronicled her life experiences in a book called *Fire on Mt. Zion: My Life and History as a Black Woman in America.* In her book, Little reflected on growing up in a segregated society and living through the catastrophic 1921 Tulsa Race Riot. (Courtesy of the *Tulsa World.*)

This April 12, 2000, photograph captures Tulsa Race Riot survivor Veniece Sims looking pensive. Sims, who was prevented from attending her own high school prom on account of the riot, attended the 2000 Booker T. Washington High School prom. (Courtesy of the *Tulsa World*.)

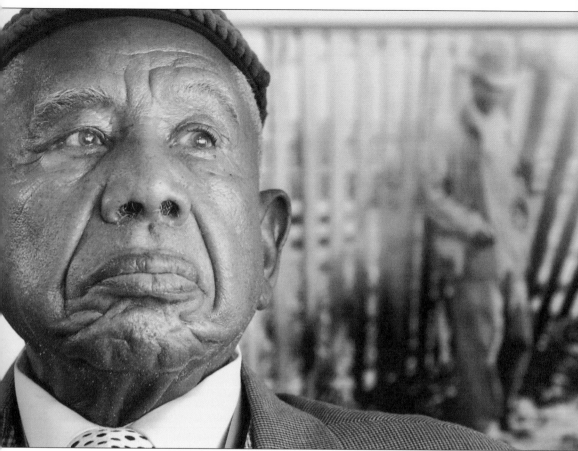

Riot survivor Otis G. Clark, 99 in this image, listens during a press conference at the Greenwood Cultural Center. Tulsa Metropolitan Ministry announced its intention to provide riot survivors with symbolic reparations payments. A world-traveling evangelist and one-time butler to Hollywood stars, Clark was believed to be the oldest living survivor of the 1921 Tulsa Race Riot. He died on May 21, 2012, at the age of 109. A minister for more than 85 years, Clark spent his last few years as a bishop with Life Enrichment Ministries, an organization he co-founded with his daughter, Gwyn Williams. (Courtesy of the *Tulsa World*.)

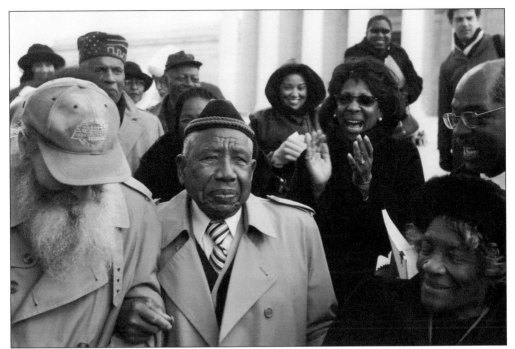

From left to right in the front row, survivors Robert D. Holloway II, 87; Otis G. Clark, 102; and Thelma Thurman Knight, 89, were applauded by Rep. Maxine Waters (wearing sunglasses) and Harvard law professor Charles Ogletree (far right, wearing glasses). The survivors were in Washington, D.C., in 2005, for the filing of an appellate brief with the US Supreme Court. (Courtesy of the *Tulsa World*.)

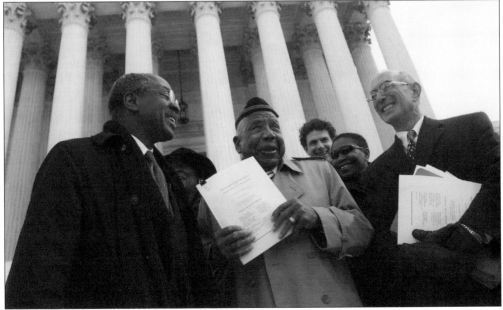

Tulsa Race Riot survivors and their attorneys hold up copies of the brief that Charles Ogletree filed with the Supreme Court, appealing a ruling that stated that they, as Tulsa Race Riot survivors, were not entitled to reparations because of the statute of limitations. (Courtesy of the *Tulsa World*.)

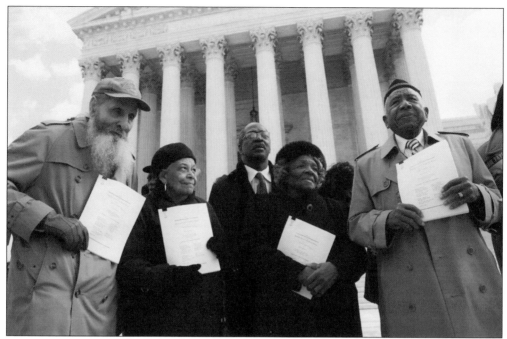

From left to right are survivors Robert D. Holloway II, 87, accompanied by his wife, Anita Holloway; Thelma Thurman Knight, 89; and Otis G. Clark, 102, holding up copies of the brief that Charles Ogletree (behind, wearing glasses), filed with the Supreme Court. (Courtesy of the *Tulsa World*.)

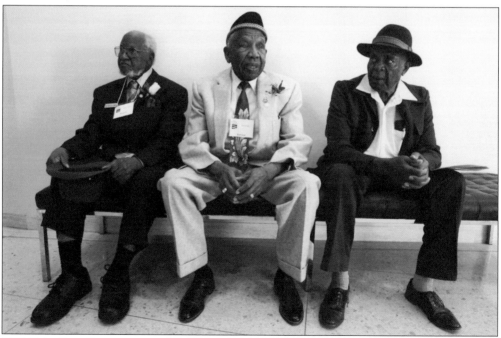

1921 Tulsa Race Riot survivors, from left to right, Wes Young, Otis Clark, and Julius Scott, relax during a reception for the premiere of a documentary about the riot at the Tulsa Performing Arts Center on October 19, 2008. (Courtesy of the *Tulsa World*.)

In Their Own Words
Riot Survivor Stories

The following excerpts from interviews by Tulsa historian Eddie Faye Gates illustrate the horrors of the riot.

J.B. BATES (June 13, 1916–December 17, 2008)
"I . . . remember that my mother was so frightened that I knew that something was terribly wrong. An airplane flew over real low and someone in the plane shot and killed [an] old man."

KINNEY I. BOOKER (March 21, 1913–March 1, 2006)
"[We] lived at 320 North Hartford Avenue. We had a lovely home, filled with beautiful furniture, including a grand piano. All our clothes and personal belongings—just everything—were burned up during the riot."

OTIS GRANDVILLE CLARK (February 13, 1903–May 21, 2012)
"I got caught right in the middle of that riot. Some white mobsters were holed up in the upper floor of the Ray Rhee Flour Mill on East Archer, and they were just gunning down black people, just picking them off like they were swatting flies."

ERNESTINE GIBBS (December 15, 1902–July 23, 2003)
"When daylight came, black people were moving down the train tracks like ants. We joined the fleeing people. . . . We had to run from there because someone warned us that whites were shooting down blacks who were fleeing along railroad tracks."

LEROY LEON HATCHER (May 23, 1921–January 31, 2004)
"My mother . . . ran nine miles with me, a nine-day-old baby, in her arms, dodging bullets that were falling near her. After the riot was over, my mother looked and looked for my father, but she never found him. His loss haunted her the rest of her life, and it ruined my life, too."

WILHELMINA GUESS HOWELL (April 25, 1907–December 18, 2003)
"My father, H.A. Guess, had a law office on Greenwood Avenue, and my mother's brother was the famous Mayo-Clinic trained surgeon, Dr. A.C. Jackson, who was so brutally murdered by mobsters during the . . . riot. The fact that the riot destroyed my father's office and led to the death of my uncle seemed very ironic to me. My relatives had come to Oklahoma to get away from racism, violence, and death in Tennessee."

SIMON R. RICHARDSON (January 2, 1914–November 28, 2003)
"Men and boys were taken by the militia to the Convention Center. In all this commotion, my grandmother didn't know where I was. I was missing from her for two days, and she was so worried. She was just sick with grief. She thought I had been killed. A few days after the riot, blacks were released from detention and most were reunited with their families."

DISCOVER THOUSANDS OF LOCAL HISTORY BOOKS
FEATURING MILLIONS OF VINTAGE IMAGES

Arcadia Publishing, the leading local history publisher in the United States, is committed to making history accessible and meaningful through publishing books that celebrate and preserve the heritage of America's people and places.

Find more books like this at
www.arcadiapublishing.com

Search for your hometown history, your old stomping grounds, and even your favorite sports team.

Consistent with our mission to preserve history on a local level, this book was printed in South Carolina on American-made paper and manufactured entirely in the United States. Products carrying the accredited Forest Stewardship Council (FSC) label are printed on 100 percent FSC-certified paper.

MADE IN THE USA